Great Design Using Non-Traditional Materials

Sheree Clark

Wendy Lyons

NORTH LIGHT BOOKS
CINCINNATI, OHIO

Great Design Using Non-Traditional Materials. Copyright © 1996 by Sheree Clark and Wendy Lyons. Printed and bound in China. All rights reserved. No part of this book may be reproduced in any form or by any electronic or mechanical means including information storage and retrieval systems without permission in writing from the publisher, except by a reviewer, who may quote brief passages in a review. Published by North Light Books, an imprint of F&W Publications, Inc., 1507 Dana Avenue, Cincinnati, Ohio 45207. (800) 289-0963. First edition.

This hardcover edition of Great Design Using Non-Traditional Materials features a "self-jacket" that eliminates the need for a separate dust jacket. It provides sturdy protection for your book while it saves paper, trees and energy.

Other fine North Light Books are available from your local bookstore, art supply store or direct from the publisher.

00 99 5 4 3

Library of Congress Cataloging-in-Publication Data

Clark, Sheree L.
 Great design using non-traditional materials / by Sheree Clark and Wendy Lyons.
 p. cm.
 Includes index.
 ISBN 0-89134-656-2 (hardcover : alk. paper)
 1. Graphic arts—Technique. 2. Artists' materials. I. Lyons, Wendy. II. Title.
NC845.C55 1996
741.6—dc20 95-44960
 CIP

Edited by Lynn Haller
Cover Photography by Gyzniwa

The permissions on pages 134-137 constitute an extension of this copyright page.

About the Authors

Great Design With Non-Traditional Materials is the second graphic design book co-authored by Sheree Clark and Wendy Lyons.

Sheree Clark is a native of Saratoga Springs, New York. Since 1985, she has been a principal of Sayles Graphic Design in Des Moines, Iowa. She has written numerous articles for graphic arts trade publications and published her first book in 1984—a history project for Drake University. Clark holds a B.S. in Retail Marketing from Rochester Institute of Technology and a master's degree from the University of Vermont. Clark's passion for design extends to her free time activities: She collects Art Deco compacts and jewelry, Lucite handbags, and industrial design and packaging from the 1930s.

Wendy Lyons is a native of Eldridge, Iowa, and enjoys writing everything from short stories to direct mail copy to books and articles about graphic design. As copywriter for Sayles Graphic Design, she has an extensive background in writing print campaigns for clients nationwide. Lyons holds a B.S. in Radio/Television from Kansas State University and is an accomplished television and corporate video writer/producer. When she's not writing, she's in her flower garden, antique shopping, or helping her husband, Gary, restore their vintage home.

Acknowledgments

We would like to thank Darcie Saylor, our enthusiastic and tireless editorial assistant. We truly couldn't have done it without you. Also thank you to our editor Lynn Haller for the ongoing support.

Gratitude is due to Bill Nellans of Gyzniwa for the beautiful job of photographing the featured projects. Thanks also to John Sayles of Sayles Graphic Design for guidance in the book's design and layout.

The real applause is due to all the designers and others who lent their work for inclusion and who shared their time and expertise.

Table of Contents

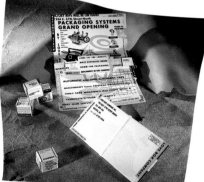

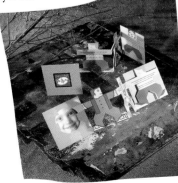

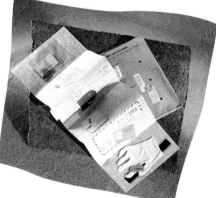

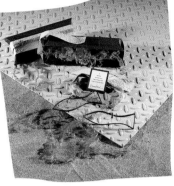
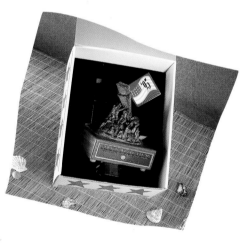

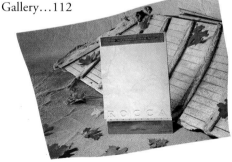
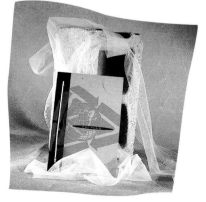

Introduction

Designing with non-traditional materials has, for a number of reasons, become a popular trend in the 1990s.

First, the field of graphic design has rapidly changed due to the widespread use of computers, both inside the design studio and out. With today's technology, many corporations choose to design their own projects in-house on the computer, allowing anyone in their company with the appropriate software to act as a designer. Professional graphic design firms have learned that using non-traditional materials in their designs helps their work stand out from the sea of mass-produced, four-color brochures on glossy white paper clogging the average consumer's mailbox. Projects using attention-getting materials such as handmade paper, acrylic, wood, found objects, metal, glass, textiles, corrugated cardboard, chipboard and unusual bindings get clients results because they are unique.

Designing on computer has also taken away the fun of touching and playing with materials. Many graphic designers have a fine art background and miss this opportunity to interact with their design medium.

The ecological friendliness of many types of non-traditional materials is also a draw for designers and their clients. Non-traditional materials often involve recycling, such as making handmade paper from paper scraps and using discarded found objects from a client's business.

Designers also appreciate the emotional impact non-traditional materials bring to their work. Recipients of a piece created from an unusual medium experience the designer's vision more than just visually—they can touch, feel, smell and even hear it. Because of their tactileness and dimension, non-traditional materials capture the client's personality in a way a traditional printed piece simply cannot.

Most of all, using non-traditional materials allows today's designers to push their creativity and talent to new levels.

This book contains outstanding examples of projects using non-traditional materials and processes by some of the world's top designers. The designers featured are as unique as the projects themselves. However, they do have a few things in common: They all want their work to create an impact, and they all enjoy the fun and challenge of designing with non-traditional materials.

John Sayles, principal of Sayles Graphic Design in Des Moines, Iowa, is recognized as an industry pioneer in designing with non-traditional materials. "Through the years, many of my designs have gradually evolved into three dimensions," Sayles explains. "My firm does a lot of direct mail and a three-dimensional format gets noticed in the mailbox. Non-traditional materials often lend themselves to these types of projects. Most importantly, unique materials can really personalize a project for a client. For example, if you can incorporate tin into a brochure for an aluminum company, the medium becomes part of the message. Why just use a picture when you can use the client's actual product—or something suggesting it—and allow the recipient to experience it on a higher level?"

The designer points out another example of why he's a fan of non-traditional materials. "I created an invitation to a family reunion using barnboards. Since the family had owned a ranch for several generations, the look, feel and even smell of the boards instantly brought back memories for the family members and made a powerful emotional impact. I just couldn't have duplicated that with a plain paper invitation."

What's graphic designer **Brian Miller**'s medium of choice? Corrugated cardboard. Since he works for Love Box Company, a division of Love Packaging Company in Wichita, Kansas, you could call Miller the King of Corrugated. Not only does he design standard corrugated packaging, he's especially fond of thinking "outside the box" to design corrugated brochures, invitations, announcements and other collateral pieces that promote his company. Miller says there's no better way to market Love Packaging. "It gets our product into the customers' hands, shows it off and demonstrates unique ways they can use it," he says.

Unlike a project printed on traditional paper, Miller feels a project created with non-traditional materials gives the impression that someone's taken time to create something special. The designer thinks using non-traditional materials is a popular trend because designers, by nature, look for ways to stand out, even looking to past decades for "new" ideas and styles. "There is so much printed material given to consumers; a marketing message designed in a unique medium is going to be heard," he says.

Chuck Johnson, principal of Brainstorm in Dallas, Texas, appreciates the ecologically responsible statement non-traditional materials make about the designer and the client—chipboard in particular. "It's made from scrap paper and wood pulp and is about as recycled as you can get," he says. "Chipboard is also affordable and readily available, so it's easy for a designer to use."

Johnson is a fan of non-traditional materials because of their ability to make people feel emotion. "A piece made from chipboard especially has a handmade feel about it. It can be very simple and child-like or have a rugged and industrial look. Chipboard is friendly. Consumers are familiar with it, so when a designer can use it in a unique way, people notice and think it's great."

If you look in the file of one of **Marc Shereck**'s design clients, you'll find something unusual: plastic bags filled with dirt, leaves and other materials unique to the client's location, product or service. Shereck, co-principal of Acurix Design Groupe in Colorado Springs, Colorado, says his firm uses this approach to get a feel for the client's business—characteristics that show up in the finished project, which is usually made in whole or in part from non-traditional materials such as stone, cloth or handmade paper. "Using unique materials is not a gimmick for us," Shereck stresses. "It's the way we work." Found objects are one of the firm's favorite design elements. "Our studio looks like a junk shop. If one of us finds a rusted wheel, some unusual weeds or an interesting feather, we pick it up and use it in our work," Shereck says.

The designer feels recycling these materials is socially responsible, and he also enjoys the result of incorporating them into his designs. "You just can't beat non-traditional materials for enticing someone to touch and read something. You can write a masterpiece on plain, white paper and no one may read it. If you use unique paper—such as a handmade paper containing indigenous materials from the subject of the writing—people will notice, read your message and remember it," he says.

An example of Shereck's design philosophy is a recent holiday greeting his firm sent to clients. "We found some old, discarded brick tiles and took them to a tombstone company that sandblasted a design of a mythological creature into them. The finished tiles were a metaphor for our studio: a matrix—or a bringing together of our design philosophy and computer technology. Our clients absolutely loved them."

Denise Sherwood's childhood on her family farm formed her appreciation of nature's beauty. After graduating from Southwestern College in Kansas, Sherwood studied art in Europe and designed publications for the community college in Dodge City, Kansas. After falling in love with Colorado Springs's flower-filled boulevards and parks, Sherwood made her escape from the flatlands to live in her Victorian home in the Rocky Mountains.

As graphic artist for the City of Colorado Springs Parks and Recreation Department, Sherwood incorporates natural elements into her design projects promoting the city. Her vision of recycling flowers from the city's flower beds to produce hand-made paper is an example of her belief in the impact of using non-traditional materials. "The paper is such a work of art," she says. "The flowers preserved in the paper perfectly capture the image of our city and the Parks and Recreation Department. Creating a brochure using this handmade paper instead of traditional paper portrays our image much more effectively. There's an emotional tie there that regular materials can't duplicate."

Why does **Gregg Palazzolo**, principal of Palazzolo Design Studio in Ada, Michigan, use non-traditional materials in his designs? "Tried and true ain't gonna work," he says. Palazzolo feels using non-traditional materials creates a higher level of design because such designs do a better job marketing themselves than those made of regular paper.

But it's not just the final results the designer's after— Palazzolo says he loves the thrill of the hunt. "Sourcing unusual materials is like an Easter egg hunt. If you discover something special and use it to create something new and exciting that's never been done before, it's like finding the golden egg. Creating a project using non-traditional materials is much more gratifying than any four-color, stochastic, waterless-printed annual report any day!" Palazzolo's advice to other designers who've never worked with unique materials? "Be a pioneer. You'll leave those who just want to use glossy paper behind."

Lisa Henkemeyer is an expert at making the out-of-the-ordinary even more unique. As specialty printing manager for Diversified Graphics in Minneapolis, Minnesota, Henkemeyer acts as a creative consultant for clients with unique design projects, helping them to create unique bindings that command attention. Choosing an appropriate non-traditional binding requires an innate sense of what materials work well together. Whether it's ribbon with chipboard or rivets with vellum, Henkemeyer says a non-traditional binding can turn a project into a work of art. "It's another way for a designer to be creative," she says.

Henkemeyer's binding techniques are inspired by her hobby of collecting odds and ends as well as some of her favorite things, including old farms, picture frames and vintage clothing. Her eye for the unusual was developed over ten years as an art director. Her educational background, including graphic design and psychology "helps me understand designers' needs and gives me the expertise to make their visions happen," she says.

Zubi Design is a husband-and-wife, architect-and-designer duo in Brooklyn, New York. Kristen and Omid Balouch's different approaches to design complement each other. Designing with wood is an important part of Zubi Design. Omid's architectural perspective gears Zubi toward wooden furniture and other wooden objects, while Kristen's background influences the surface designs. The couple works with an unusual range of form and function, from furniture, boxes and toys to books, promotionals and other print pieces.

Wood is one of the design team's favorite mediums to work in because "the warmth and feel of wood has a richness unlike any man-made material. This translates graphically into substance and depth," Kristen says. The designers point out that each piece of wood has its own personality that comes shining through in the design. Another reason Zubi Design enjoys designing with wood is its lasting appeal—something paper lacks. "Wood brings an immortality to our work," Kristen says. "It's very rewarding to create an object that's going to last and be enjoyed for a long time."

Robert Little, principal of Blue Sky Design in Miami, Florida, says his firm is sold on designing with non-traditional materials because they capture the essence of a client much more effectively than printed paper. In projects such as menus, Blue Sky Design likes to tie their menu design into the interior decor of the restaurant by using unique materials such as metal and fabric.

Little says his firm likes doing projects that get noticed. "Non-traditional materials add flair and excitement to a piece and make it jump out from the other ninety seven things the consumer may have in front of them." Little especially likes the hand-crafted, high-quality feel unusual media bring to his firm's work. "A designer's goal is to get across a message. Someone is much more likely to want to pick up and explore a brochure or other piece if they've never seen anything quite like it."

Alan Potash of Jerusalem Paperworks in Omaha, Nebraska, doesn't design on paper—he designs the paper itself. After learning the art of papermaking at Southern Illinois University, Potash got the idea of photographing landscapes and then printing the photo on paper he made from materials gathered from the scene.

After college, Potash moved to Israel where he started making paper from materials indigenous to that part of the world and selling his unique paper as stationery. Potash relocated his family back to Omaha during the Persian Gulf War and began marketing his unique style of handmade paper to designers, allowing them to incorporate materials from the client into paper. Potash says his paper adds another dimension to a design. "A project becomes more than just ink on paper; the image and the paper come together in a way that evokes an emotion."

Caroline Vaaler, principal of Three Fish Design

in Norfolk, Virginia, says she likes to design with non-tradition-al materials because it's challenging and fun. "After a day designing on the computer, it's nice to do a project where I can get back to the 'craft of design.' It's refreshing to work with my hands and feel the material I'm working with," she says. Vaaler experiments with a different medium each year for her firm's holiday promotion. "I look forward to it. It's very rewarding to constantly learn and grow as a designer by using new and unique materials," she says.

Vaaler stresses that non-traditional materials are unmatched for attracting attention and keeping it. "That's what graphic designers try to do—get the recipient to open a piece, turn the page and read the client's message." Vaaler points to the success of their own promotional projects as proof non-traditional materials get results. "When I visit my clients, they still have my pieces in their offices. That's why I'm a believer!"

Sam Zell and **Peter Szollosi** are idea-

driven. Zell, founder of Chicago-based Equity Group Investments, and Szollosi, the firm's creative director, specialize in coming up with unique ideas for custom gifts promoting the commercial real estate empire and bringing them to life. They say their favorite response to a piece they've created is: "I can't believe you did this!" Since the audience for Zell and Szollosi's creations are the world's financial movers and shakers, the pair only uses quality materials and puts together a first-class team of craftspeople. "Non-traditional materials enhance the perception of a project's value," Szollosi says. "My goal is not to purchase something pre-made from a catalog. A custom-designed gift is more valuable to the recipient and reflects the quality of our company much more accurately."

Zell and Szollosi have this advice for other designers consid-ering non-traditional materials: "Don't limit yourself to what you think is cost-effective. Try using different materials of the highest quality you can find. You'll probably discover the costs won't be out of line." The pair also stresses the importance of seeking out experts in your chosen medium. "Be creative and think about what types of industries use a particular material. The vendor may never have created anything like your project before, but they're often eager to try something different."

Found objects and other non-traditional materials are traditional for **Anita Meyer** (above left) and **Jan Baker** (above right); the usual approach of printing on paper would be unusual for them. Meyer, co-principal of plus design, inc., in Boston, Massachusetts, and Baker, artist and professor at Rhode Island School of Design, believe the automation of today's designs loses the human touch. "Using everyday objects in a design adds an element of surprise and captures someone's or something's essence in a way a plain printed piece can't," Meyer says. "How do you print the color of the sky when the sun is setting? The true textures of life are unobtainable through traditional materials."

When creating a project for a client, Meyer and Baker say their goal in using found objects is to make the recipient "feel" what makes the client unique. Baker gives an example of their approach. "If we did a piece for a corporation, instead of taking a picture of a company's executive, we'd include a piece of his pinstripe shirt and the texture of his cuff-links. These things capture who he is more than words or a picture."

Meyer and Baker have this advice for other designers who'd like to experience design with found objects: "Look at everyday objects you use and think about what they communicate. Before you throw them away, brainstorm about how the objects can be used in a design piece to express a message."

Designing with Corrugated Cardboard

Love Packaging Group

Brian Miller has left the world of flat, plain paper behind. As a graphic designer for Love Packaging Group, a division of Love Box Company in Wichita, Kansas, Miller spends a lot of his time designing boxes that sit in warehouses. So when he had the opportunity to design a collateral piece promoting his company, he turned to the medium he knows best—corrugated cardboard.

CREDITS:

Design Firm/Client:
Love Packaging
Group/Wichita, KS
Graphic Designer: Brian
Miller
Structural Design: Daryl
Hearne
Corrugated: Love
Packaging Group/
Wichita, KS
Screenprinting: Rand
Graphics/Wichita,
KS
Quantity Produced:
2,000

Miller designed a unique invitation to the grand opening of Love Packaging Systems, a factory simulation building where potential clients can try out packaging and warehousing machinery before they buy it. Because the building would be the only one of its kind in the country, the event would be a memorable one, and Miller wanted the invitation to convey that.

The invitation's target audience was people who purchase equipment for warehouses that move packaging; this audience works in warehouses and is surrounded by mundane, brown boxes all day. Miller knew that in order to motivate his audience to respond to the piece, the invitation would have to speak their language—corrugated packaging—but with attention-getting flair.

The resulting invitation is a shallow, rectangular box with three-color typography and graphics reminiscent of industrial box stamps. On the invitation, photos of packaging equipment are printed in large, benday dot patterns—an old style technique using screens with large dots to print photographic images. A die-cut corrugated "arm" wraps around the invitation. A tab on the end of the arm slips into a slit to hold the invitation shut. The recipient opens the arm, then unfolds the corrugated to discover more industrial-looking graphics and information about the grand opening event.

Every surface of the box—from the inside and outside to the arm closure and end flaps—is filled with typography and graphics. "Back in the 1920s and 1930s, package designers used every single surface of a box and didn't waste any space. They saw each panel as an opportunity to communicate a message. I tried to capture this look and feeling," Miller says.

Inside the mailing are four smaller, unfolded boxes, each containing copy and graphics promoting a different packaging machine. The small boxes also serve several other purposes: When they're folded up, they give a three-dimensional element to the invitation and are likely to be kept on someone's desk as an on-going reminder of Love Packaging Systems; pragmatically, they fill the empty space inside the invitation itself and use up the waste area on the corrugated sheet left by the die-cut.

Another ingenious feature of the invitation is that the arm and the end flaps are perforated so they can be removed; the box can then be unfolded to a rectangular shape and hung as a poster. Miller says he pulled out all the stops on this invitation because it gave him the opportunity to show clients how corrugated can be used creatively.

The invitation was sent to 2,000 people. "Everyone loved the tactileness of this piece," Miller says. "They enjoyed interacting with it. The first thing they did was put the little boxes together." The designer says he attributes the invitation's success to the power of non-traditional materials in design. "A plain, paper invitation would not have had the same impact," the designer points out.

1 Miller started the design process by producing these sketches of possible shapes for the invitation. He knew he wanted a three-dimensional format, but since the invitation would be sent through the mail, he kept size and shape in mind. Miller took his favorite sketch to Love's structural designer, Daryl Hearne, who produced the paper dummy shown here. After Miller approved it, Hearne used a **CAD** system to make a corrugated prototype. Because the piece was to be mailed, Miller chose the lightest weight of corrugated that would hold its shape and fold easily.

2 Using the prototype shown here as a guide, Miller began to sketch graphics, experimenting with how they'd fit on the shape of the invitation; he wanted to fill every surface with visuals. Because he planned to have the piece printed in-house on a flexo-press, and since items have a tendency to shift during this process, he chose to use big, bold typefaces and graphics. The designer wanted the graphics to have a random pattern, suggesting the stereotypical warehouse box, so he didn't worry about the graphics registering exactly. Miller originally wanted to print in two colors—black and green—and use a screen of the green to add subtle shading to his design. Because of the large dot gain associated with flexo-printing, however, screens cannot be easily achieved, so the designer added a third, lighter green color to his graphics.

3 During the graphic design stage, Miller refined the shape of the corrugated invitation and passed his changes to Hearne, who made him a new prototype. When Miller was satisfied that his graphics would work with the invitation's shape, Hearne converted his **CAD** drawing of the invitation to a Mac **DXF** file; then through a Mac program called **Canvas** to a **PICT** file. The **PICT** file was then imported to Aldus Freehand where it was used as an overlay with the graphics.

To reproduce photographs of the machinery on his invitation, Miller used Adobe Photoshop. He scanned the photos into the computer, then specified a low line screen with a round dot pattern for the halftone, to give an old-style graphics look to the photos. The designer laid out his type and graphics in Freehand. He printed numerous test pages before he was satisfied. Miller output his final design and taped it together for the front and back of the piece. Then he printed the die drawing of the invitation on mylar and laid his graphics under it to make sure they fit. The designer says testing your design by printing it is a critical step.

Tips for great design with corrugated:

🌿 To get samples from a corrugated manufacturer or distributor, look in the phone book. If there is no vendor in your area, go to the grocery store and look for the manufacturer's stamp at the bottom of a corrugated box.

🌿 In the design stage, keep in mind what printing method you'll use for the project. Flexography is commonly used to print corrugated, but is usually practical only for large runs and for designs with few fine details. Screenprinting is another alternative if your design involves more detail. But to get the best results from a detailed design, offset print the liner paper alone, then have it glued to the corrugated flute by the manufacturer, or use a spot offset label glued to the corrugated.

🌿 If you're designing packaging on any computer drawing program, make sure you're working on the correct side (inside or outside) of your package. Designers often design on the inside of a box when they actually want the graphics on the outside. Double-check yourself by looking at the score marks and laying your graphics under—rather than over—the structural die drawings.

🌿 Each weight of corrugated will print differently. When you print a project on corrugated, ask the manufacturer to trim out a few sheets of other weights and put them into the print run so you can experiment and learn.

🌿 Try embossing and debossing corrugated flutes to add a unique design element to a piece.

🌿 For small corrugated print runs, try your local sign or clothing screen-printer. They can often print corrugated for a fraction of the cost of a large printer or manufacturer.

🌿 Rely on your corrugated supplier to help you determine the correct kind and amount of corrugated to buy for your project. Corrugated is available in different flute sizes and in both double- and single-wall. It's priced by the test weight—the weight that will crush the flutes—and sold by the square foot. The color of the paper liner—the paper that is laminated to the flutes to produce corrugated's outer walls—also affects corrugated's price. The color is determined by the refinement level of the paper. Three colors of liner paper are readily available: bleached white paper is the most expensive, mottled white costs less, and brown kraft paper is the cheapest. Some manufacturers also offer liner papers in custom colors.

🌿 After creating a working prototype of your design, take it to your corrugated manufacturer. They can usually produce a prototype with their **CAD (Computer Aided Design)** system and give you a die template on mylar or computer disk.

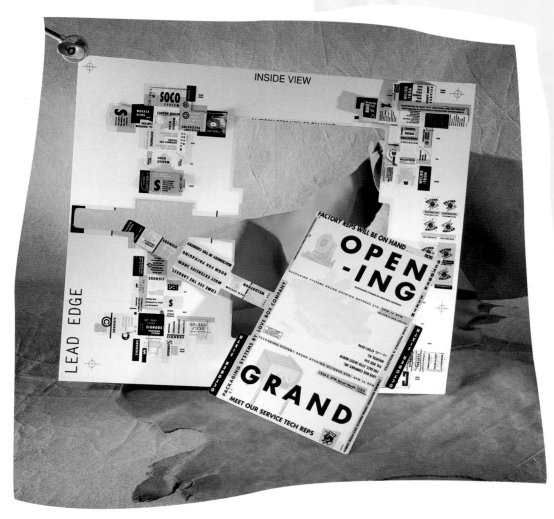

INSIDE VIEW

LEAD EDGE

Other design uses for corrugated:

- Table tents
- Brochures
- Shelf tags
- Hang tags
- Point of purchase displays
- Invitations
- Announcements
- Folders
- Binding reinforcement
- CD and cassette tape jewel case liners
- Rolodex cards
- Belly bands
- Name tags
- Business cards
- Packaging

4 At this point, the designer discovered flexography would not be cost effective for a 2,000-piece run because of the high cost of flexo-printing plates, which came from an outside source. He decided to screenprint the invitation. He took his graphics on paper and mylar film to the screenprinter and had them printed in three colors on mottled white E flute corrugated. Miller had the printed corrugated die-cut by Love Box Company's Bobst die-cutting machine, to achieve the results shown here.

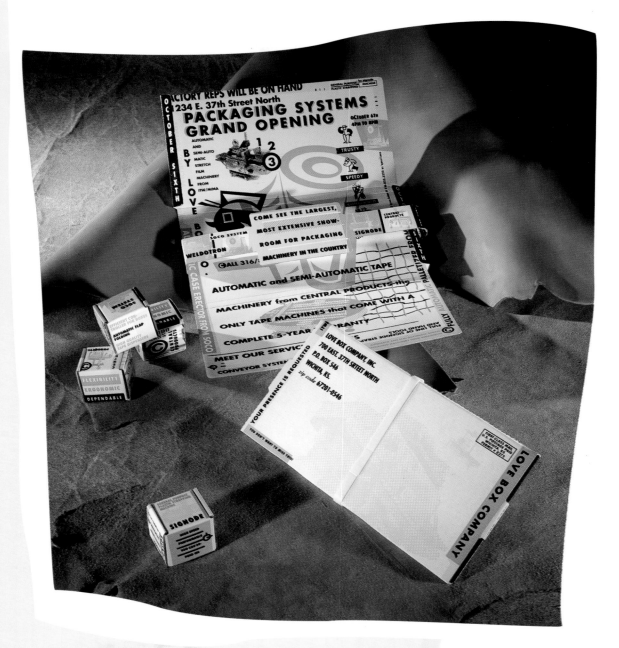

5 The invitations were assembled in-house. In a unique method of targeting his audience and showcasing his company's capabilities, Miller had some mailings customized according to the recipient's packaging needs. If a potential client used plastic banding in their packaging, their invitation was put through Love's banding equipment and mailed with a plastic band around it. Other invitations were shrink-wrapped, then hand-delivered.

Gallery

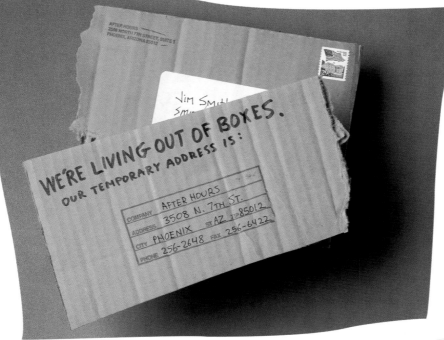

This simple and cost-effective moving notice gets the point across beautifully. Printing was achieved with rubber stamps and large markers. The corrugated used was actually torn pieces of moving boxes. Design Firm: After Hours Creative

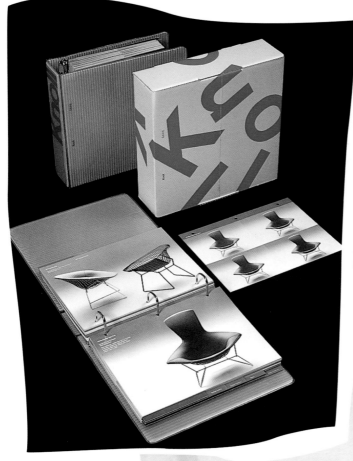

Corrugated plastic has potential for use where conventional corrugated cardboard would not work, as shown in this catalog project for a furniture manufacturer. A frosted corrugated plastic is encased in layers of clear vinyl to form this otherwise conventional notebook. Both the corrugated plastic and the clear vinyl were screen-printed, to achieve a multi-level look. The box is corrugated cardboard. Design Firm: Matsumoto Incorporated

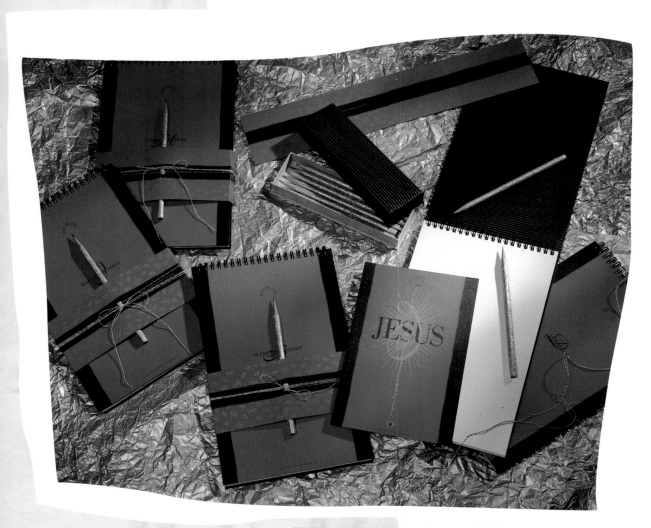

This project involved production of 250 holiday cards and 41 handmade notebooks, which were given to clients as gifts. Black single-wall corrugated was spray mounted onto cover weight paper stock to create the notebook covers. The inside pages were trimmed by a local printer, then sent with the spray-mounted covers to be wire-bound. To finish off the project, crinkled gold tissue was adhered to round, eraser-less pencils with spray adhesive. Design Firm: Detter Graphic Design

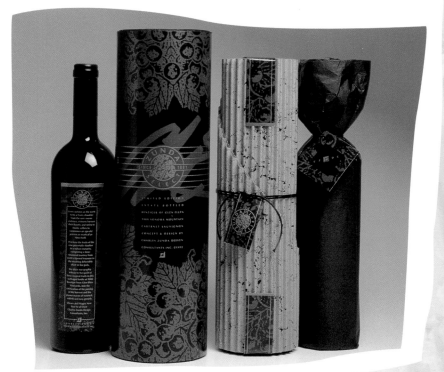

Employees of the design firm that sent this self-promotional holiday wine gift provided the labor for the project, including hand-splattering the corrugated E-flute protecting the bottle. A webbing spray paint—manufactured by The Carnival Arts Company of Mundelein, Illinois—was used. A total of 150 gifts were produced at a cost of just under $10,000. Design Firm: Charles Zunda Design Consultants

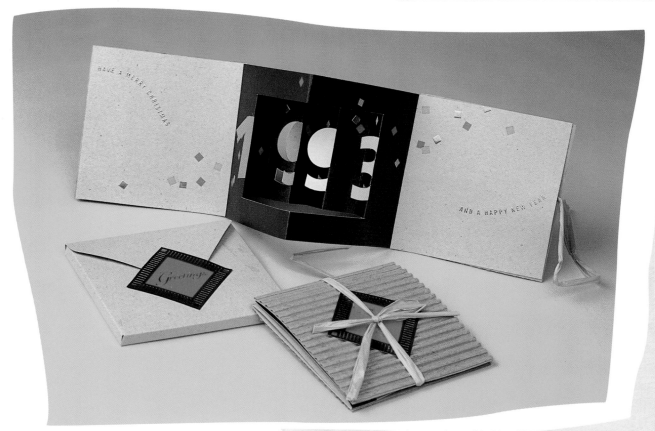

A great deal of handwork went into this New Year's greeting card. Since single-wall corrugated is sold in rolls, the first step in the process for the cover was to cut the material into sheets. These sheets were then die-cut into the exact size required and glued onto the printed part of the greeting. Each piece was hand-glued, folded and tied with raffia. Design Firm: Julia Tam Design

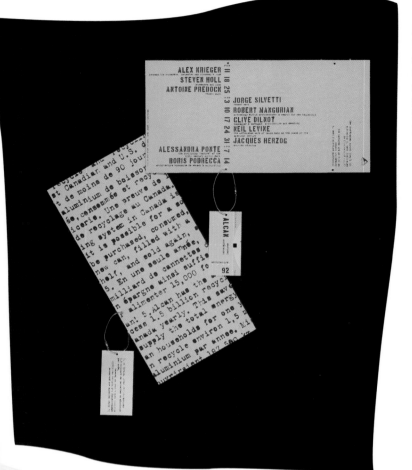

Recycling and process are emphasized in this poster announcing an architectural lecture series. Printed on corrugated cardboard, with typography generated by stencils and an antique typewriter, the materials and techniques allude to recycling and process in architecture. Each tag, recycled from the previous year's poster press sheets, is imprinted with one of a variety of recycling facts. Design Firm: plus design inc.

Chipboard and single-wall corrugated are the primary materials used in these unique thank-you notes. To keep the end caps on the column, the corrugated cylinder is rolled somewhat loosely, so that its circumference is larger than the hole in the end cap. Then, when the cap is pressed on, the ripples in the corrugated compress slightly to make a firm seal. The firm produced 200 thank-you columns, sent via mail in mailing tubes. Design Firm: Studio M D

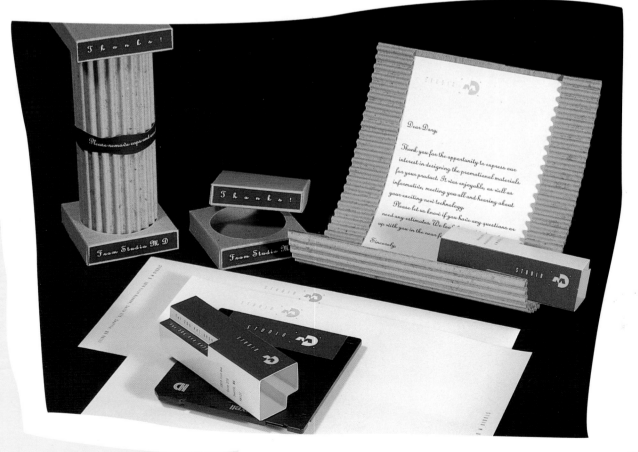

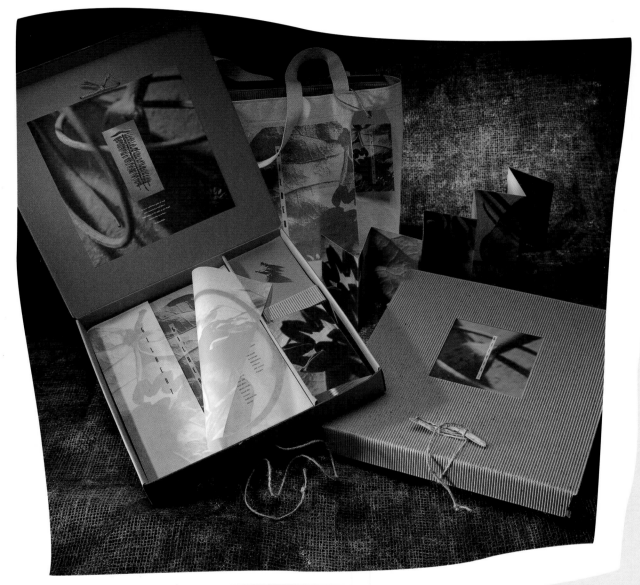

A stock corrugated box usually used for pizza is transformed into a special presentation piece in this labor-intensive promotion for a paper mill. E-flute corrugated was adhered to the stock boxes by a box company. Held closed with jute twine and a twig, the designer says that finding enough of the 6" sticks posed a challenge. **Design Firm: Grafik Communications Ltd.**

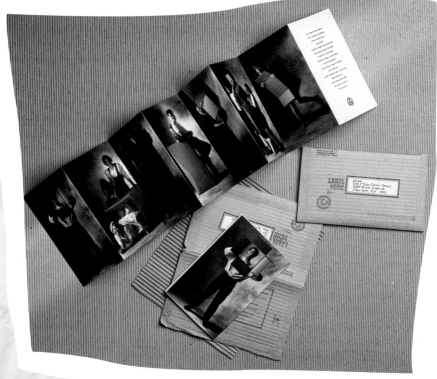

Single-wall corrugated was folded and taped with standard package tape to make envelopes for this mailing announcing a design studio's change of address. The envelopes were then hand-stamped with custom stamps, saving the cost of printing. A total of 1200 mailers were produced. Production costs were kept low due to trade-out agreements with suppliers. **Design Firm: Mires Design**

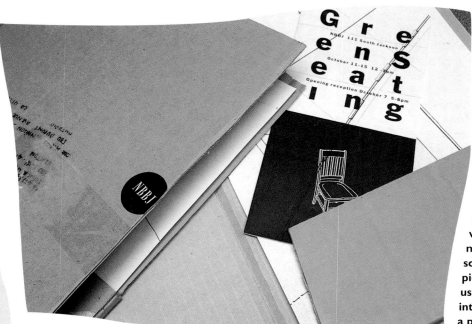

Material costs for this announcement for a recycled furniture show were extremely low due to an innovative approach. Used boxes were made into pocket folders by hand-scoring and folding large, single pieces. The brochures are made from used blueprint paper, which was cut into 8¹/₂" x 11" sheets and run through a photocopier. The designer says that although used blueprint paper photocopies easily, the quality is not always consistent. **Design Firm: NBBJ Graphic Design**

Designing with Chipboard

Since non-traditional materials add a gift or keepsake quality to a piece, many graphic designers use holiday promotions to experiment with them. And since the holidays are also a time when mailboxes are flooded, a mailing done in a three-dimensional format or made from a unique material will stand out from the rest.

Chuck Johnson of Brainstorm, a Dallas-based design firm, used chipboard to create an attention-getting holiday card for Yaquinto Printing. The printing company wanted a piece it could send to its clients and vendors announcing a donation made in their names to the Children's Medical Center of Dallas. Johnson struck a deal with Yaquinto, agreeing to design their holiday piece if Yaquinto would print Brainstorm's holiday promotion.

Yaquinto Printing's "Holiday Shapes" greeting card features a square cover in raw chipboard. In the center of the cover is a brightly colored graphic of a Christmas tree printed on a coated cover paper and adhered to the chipboard. When the recipient opens the card, colorful, die-cut "paper dolls" unfold from the chipboard cover. The figures are offset printed in four-color process on a coated cover stock. The chipboard front and back allows the card to stand up. Copy containing Yaquinto Printing's holiday message is printed on the last figure, which is adhered to another square piece of raw chipboard.

Johnson says the paper dolls represent children. "Children come in all shapes and sizes. That's where we got the name 'Holiday Shapes,'" the designer says. Johnson wanted the piece to have a child-like feel, to tie in with the donation to the Children's Medical Center announced in the card. "The raw chipboard definitely adds a handmade look to the card," he says. To make the point that no two children are alike, Johnson had each designer in his firm illustrate a doll, so that, while each doll in the row is the same size and shape, each has its own distinct personality.

"This piece evokes an emotion in the recipient," Johnson says. "People remember cutting out paper dolls and paper snowflakes as a child, and the card echoes the fun and innocence of those times."

CREDITS

Design Firm: Brainstorm/Dallas, TX
Client: Yaquinto Printing/Dallas, TX
Art Director/Creative Director: Chuck Johnson
Illustrators: Bryan Flynn, Rob Smith, Chuck Johnson, Ken Koester
Photographer: Will Crocker
Off-Set Printing: Yaquinto Printing/Dallas, TX
Die-Cutting: Process Engraving/Grand Prairie, TX
Chipboard: Clampitt Paper/Dallas, TX
Quantity Produced: 500

Know your chipboard

(Listed in order from cheapest to most expensive)

Plain chip or tan bending chip: Is made from recycled material, is uncoated, and comes from the mill light gray, dark gray and tan. You can only specify the exact color if your quantity is very large.

Double kraft: Two sheets of tan kraft with a layer of plain chip inside; is recycled.

Solid kraft: Tan in color, usually virgin fiber.

White clay-coated newsback: Is plain chip on one side and has a white clay coating on the other.

White clay-coated kraft-back, also called solid unbleached sulphate: Is tan kraft (virgin) on one side and has a white clay coating on the other.

Solid bleached sulphate: Is a kraft material, white in color all the way through. This is the highest quality of chipboard and is desired for its smooth printing surface.

1 Johnson sketched out a design for the card on paper. He then called his paper supplier and requested samples of packing board and chipboard so he could experiment with different weights.

2 The designer chose a chipboard sample based on its simple look and durability, and then made a dummy out of it. After finalizing the shape of the paper dolls, he drew a template on the computer using Adobe Illustrator.

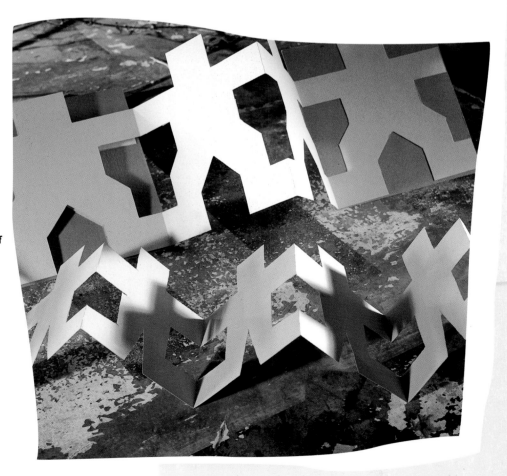

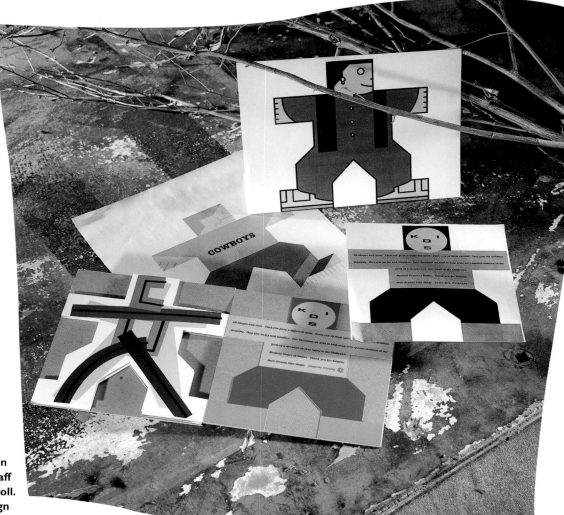

3 Each designer on Brainstorm's staff illustrated a paper doll. Some did their design on the computer using Johnson's template, while others designed on paper and scanned their art into the computer. No two paper dolls are alike: some are realistic and others feature an abstract style. One even features a four-color photograph provided by the client—a child's face. The type was set on the computer using Johnson's template.

Other design uses for chipboard:

- Brochures
- Invitations
- Announcements
- Greeting cards
- Point of purchase displays
- Posters
- Packaging
- Folders
- Annual report covers
- Business cards

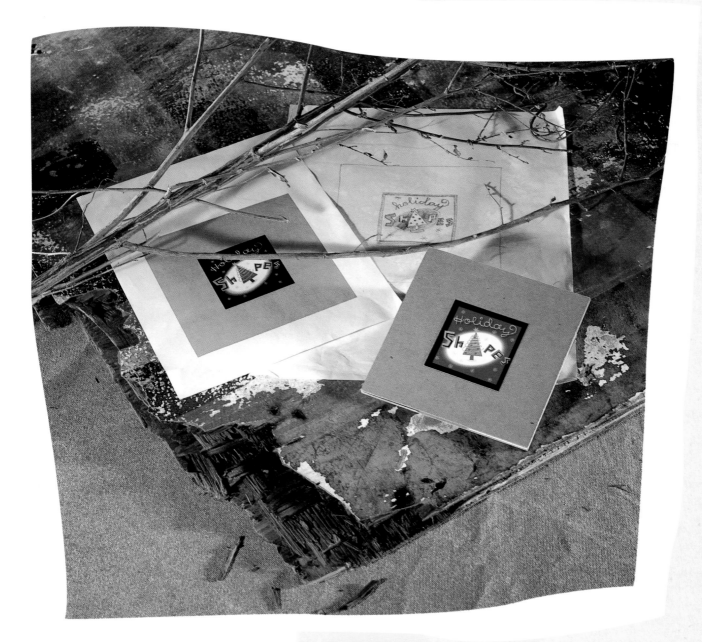

4 When the design was complete, Johnson made a laser-printed paper dummy, then gave Yaquinto Printing the art on a computer disk. The printer did the color separations and offset printed the paper dolls and cover graphic on a coated cover stock. The paper dolls were die-cut by a specialty engraving company. Yaquinto Printing cut the chipboard into 6" x 6" squares and then glued the paper dolls and cover graphic to them.

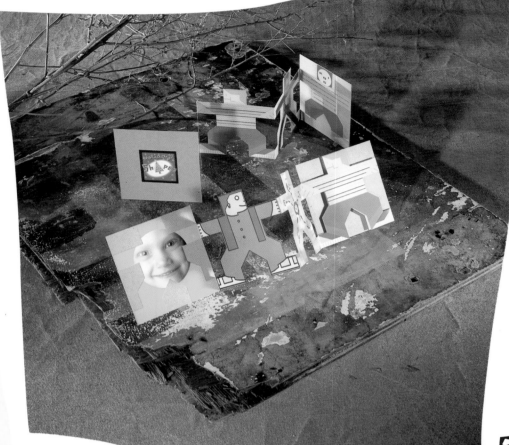

5 The finished card was mailed in a 6½" square stock envelope to five hundred of Yaquinto Printing's clients. The entire project took three weeks to complete.

Tips for great design with chipboard

Chipboard is made from recycled paper and wood scrap pulp. It is sold by the sheet or bundle. Common sheet sizes include 22½" x 34½", 26" x 38" and 28½" x 34½". The thickness of a piece of chipboard determines its weight. The weight is measured in points, with 16- to 80-point weights being the most common.

Chipboard is priced according to its type and thickness and is available through most paper companies, box manufacturers and art supply stores. Prices of chipboard vary depending on where you purchase it.

Chipboard has a tendency to warp slightly, parallel to the grain direction. For certain pieces this may add to chipboard's "handmade" appeal. Keep the style of your project in mind when deciding whether to use chipboard: If a piece needs to look particularly elegant or perfect, chipboard may not be a suitable choice.

Chipboard is usually printed by silkscreening or flexography. You can also offset print label or other paper stock and adhere it to the chipboard.

Chipboard can be cut by die-cutting with a guillotine cutter; lighter weights can be cut with scissors or an X-Acto knife.

Try using chipboard in a project where you'd usually specify heavy weight cover paper, such as brochure covers, folders and postcards.

To bind chipboard, try Wire-O, Chicago screw posts, O-rings, hand-tied bindings, or securing an object such as a rod or bead with a band of material through a punched hole.

If you're designing chipboard packaging, always get a sample of the product going into it. Make a prototype of the structural design first and place the product inside to test for durability.

Gallery

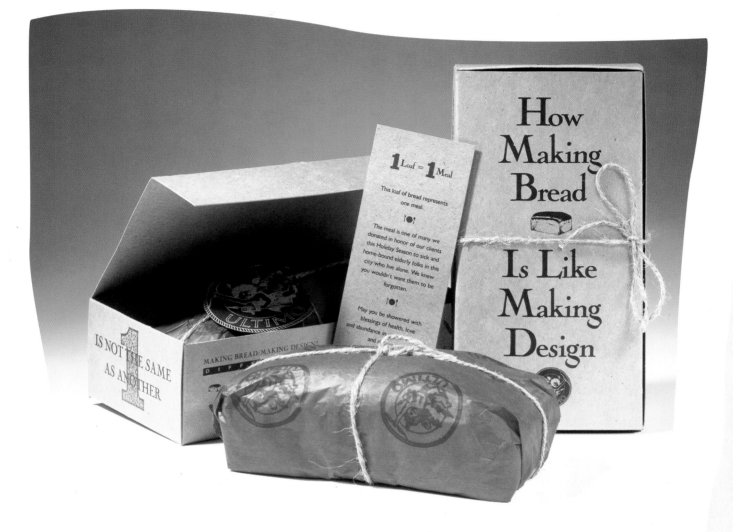

This custom chipboard box houses a loaf of bread and holiday greeting. The box and bread were sent to a select group of clients and friends, while the accompanying card went to a longer list. Inside each card is a stalk of wheat (not visible in photo), which provided its own challenge: The stalks kept breaking in the mail. Seeking an ecologically-sensitive solution, the designers sourced a citrus-based varnish, which protected the wheat as well as providing a pleasant scent. Design Firm: Ultimo, Inc.

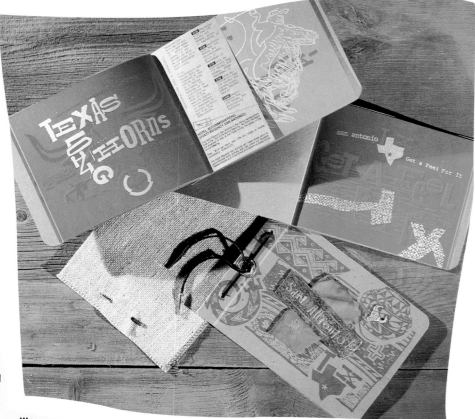

After arriving in the burlap bag shown in the lower left, this brochure makes an impact. Leather, sheet metal, a silver stud and a suede thong adorn the chipboard cover of the mailing to promote a conference in San Antonio. The chipboard was varnished, die-cut and scored before being hand-bound with the interior pages. Design Firm: Sayles Graphic Design

Chipboard takes on an almost elegant look when foil-stamped, as in this folder and corporate brochure combination. The foil did need to be hit twice to achieve the proper color saturation, but the designer says the extra time and expense was worth it. Design Firm: Shimokochi/Reeves

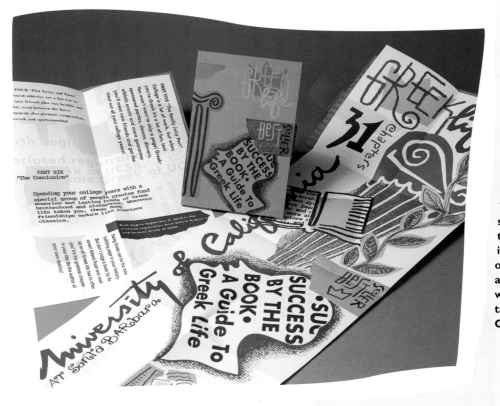

In keeping the "book" theme of the mailing, this mailer has a chipboard exterior wrap, which resembles a book jacket. The contrast of fuchsia foil-stamping on chipboard adds to the dramatic effect. The inside information is printed on text-weight paper adhered to the chipboard with double stick adhesive tape. Design Firm: Sayles Graphic Design

Two pieces of chipboard form the front and back covers of this design firm's holiday greeting. Four-color illustration panels were hand-glued to the covers by the firm's own staff. The illustration panels were scored and folded at various angles to add interest. Design Firm: Brainstorm, Inc

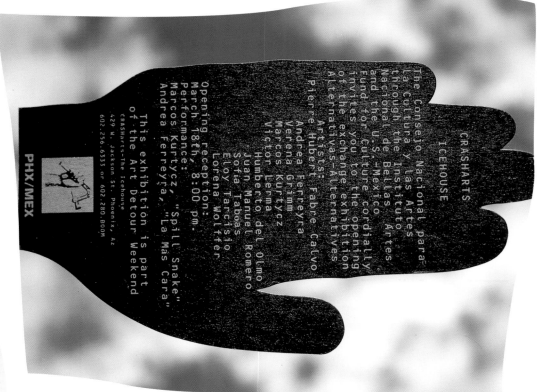

Graphics of hands are used to symbolize artists in these invitations to two shows: one held in Phoenix, the other in Mexico. In addition to conventional ink, the designer specified the use of thermography, which gave an appealing contrast in texture to the chipboard. The chipboard sheets had to be hand-fed into the printer's equipment because of the invitations' large size. Total production costs were $500 for 1,000 of each invitation. Design Firm: Campbell Fisher Ditko Design

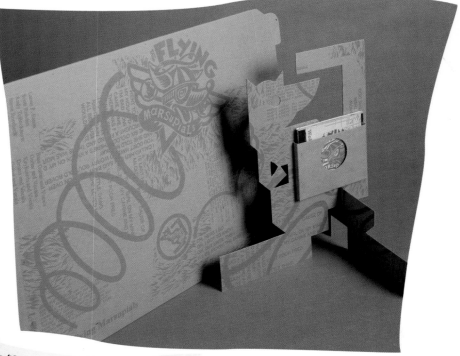

An in-store display unit for the band "The Flying Marsupials," this piece is cost-effective to produce because of the materials used. Stock 21" x 17" chipboard envelopes were printed with varnish to match the die-cut chipboard interlocking display unit. Design Firm: Sayles Graphic Design

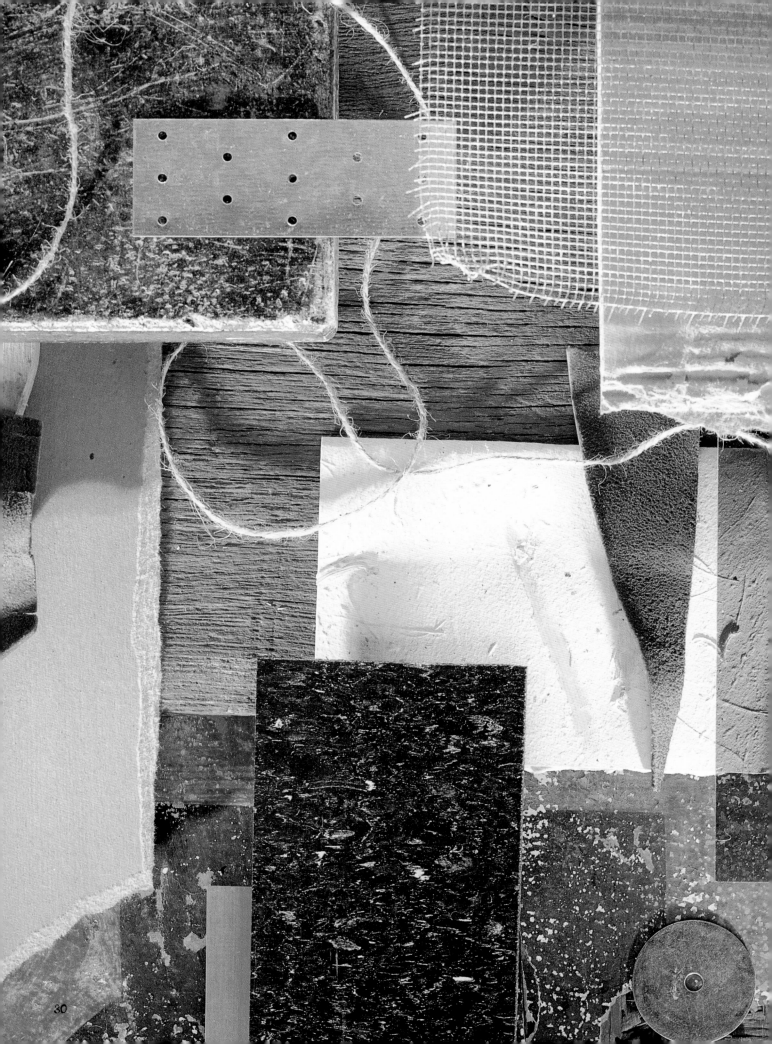

Designing Custom-made Paper

Colorado Springs Parks and Recreation Department and Jerusalem Paperworks

Graphic designer Denise **Sherwood** was stumped: She needed a unique idea for a special brochure to promote the Parks and Recreation Department of Colorado Springs, Colorado. Then **Sherwood** read an article in a design magazine about a project for a city's solid waste department using handmade paper containing "trash." Driving home past the award-winning gardens gracing Colorado Springs's city parks and street medians, Sherwood knew she'd found the way to make her project memorable—she'd harvest flowers from the city's gardens after the end of the growing season and use them to create handmade paper for her brochure.

CREDITS

Client: Colorado Springs Park and Recreation Department/Colorado Springs, CO

Art Director: Denise Sherwood

Paper Designer: Alan Potash/Jerusalem Paperworks, Omaha, NE

Quantity Produced: 2,400

Sherwood took her idea to the six-member team working on this and other image-related projects to promote the Parks and Recreation Department, and they laughed. They couldn't imagine paper made from flowers. But Sherwood was determined. She called the designer of the "trash" piece and discovered his source for the unique paper—Jerusalem Paperworks in Omaha, Nebraska. Sherwood asked Jerusalem Paperworks's paper designer, Alan Potash, to send samples of his work to her; when she presented these samples to the members of the team, they were impressed and approved Sherwood's concept.

Designing with handmade paper is nothing new. However, using special paper conceptually to tie together a client and their design project is an innovation. Jerusalem Paperworks specializes in designing paper that is custom-made to reflect a company's identity. Potash meets with designers and clients by phone or in person, and then makes a sample of their paper for approval. Jerusalem Paperworks has created paper using raw honey for a Sue Bee Honey brochure and has used shredded money to create custom paper for a bank; fabric, soybeans, corn husks, coffee beans and rose petals are other ingredients Jerusalem Paperworks has incorporated into paper. Jerusalem Paperworks's custom handmade paper costs approximately 50 percent less than other handmade paper and is competitive with high-end commercial paper. And this custom handmade paper adds a visual and emotional element to a project that commercial paper doesn't.

For designers who'd like to try making their own handmade paper, Potash recommends the following books:

Japanese Papermaking Traditions, Tools and Techniques by Timothy Barrett (Weatherhill, 1983)

Papermaking; The History and Technique of An Ancient Craft by Dard Hunter (Knopf, 1978)

Papermaking by James Heller (Watson-Guptill)

Papermaking kits are also available in art supply stores. Potash encourages designers to call Jerusalem Paperworks if they have specific questions about papermaking techniques.

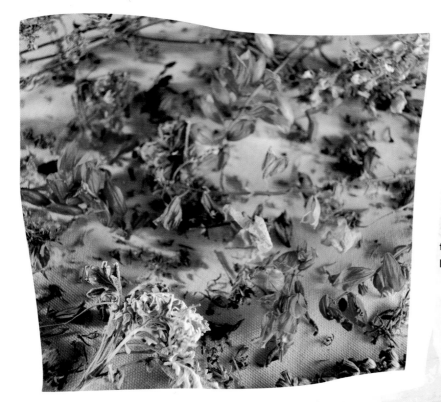

1 After the growing season was over, Sherwood and Annelle Marshall from the Colorado Springs's horticulture staff harvested flowers from the city's gardens, compost pile and greenhouse, then shipped them to Jerusalem Paperworks. Paper designer Alan Potash chose the most colorful, interesting flowers and greenery for the paper.

2 Potash then shredded white paper scraps and brown paper grocery bags in an industrial mixer. Potash gets his paper scraps from various sources such as recycling programs, printers and grocery stores. (If a sturdier handmade paper is required, Potash uses virgin cotton fibers from paper suppliers. However, then the paper is not 100 percent recycled, and handmade paper's ecological benefit is important to many clients.)

Design uses for handmade paper:

- Annual report covers
- Invitations
- Packaging
- Corporate identity
- Stationery
- Folios
- Brochure covers
- Greeting cards

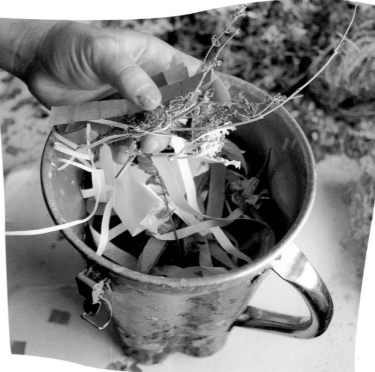

3 To make paper pulp, the shredded paper and flowers were added to water in a blender and blended to the consistency of oatmeal. Sherwood wanted a natural colored paper for her project, but if she had wanted colored paper, Potash would have added a fabric dye to the pulp at this step.

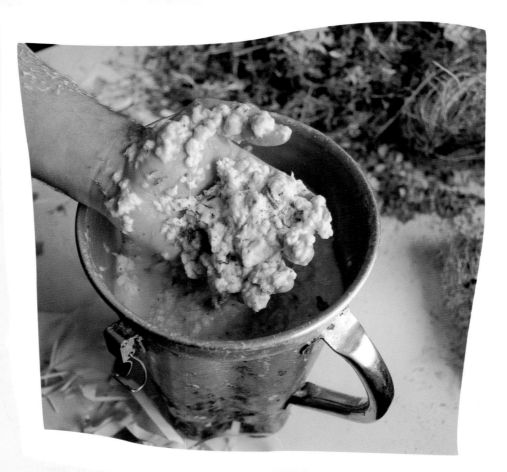

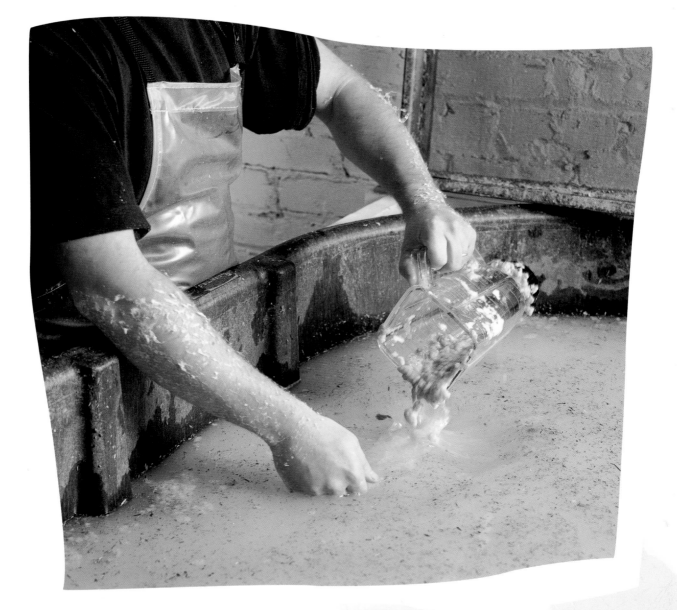

4 Potash added the pulp to large troughs full of water—one part pulp to nine parts water—and stirred.

5 He then dipped a wire mesh screen into the water/pulp mixture and slowly raised it to the surface using a back and forth motion. Many types of screens are used in paper-making including copper, wire mesh, nylon material and silk; the finer the screen, the smoother the paper will be. A 24" x 36" sheet size is standard, but Potash can produce sheets of any size by using an appropriately-sized screen. As the water ran through the screen, an even layer of pulp was left. At this point, Potash could have arranged additional flowers in the pulp, if desired.

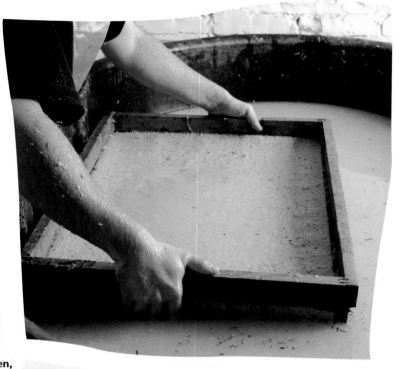

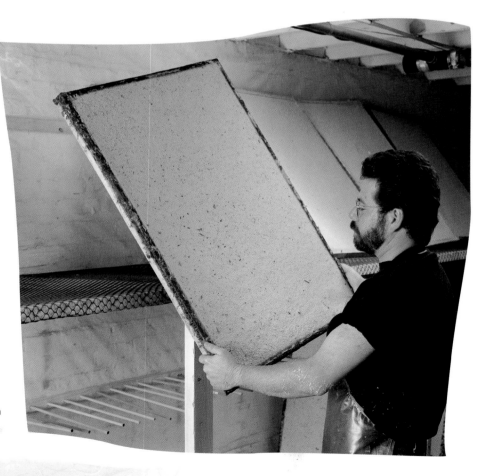

6 The screens with wet paper were put on racks to dry for 24 hours.

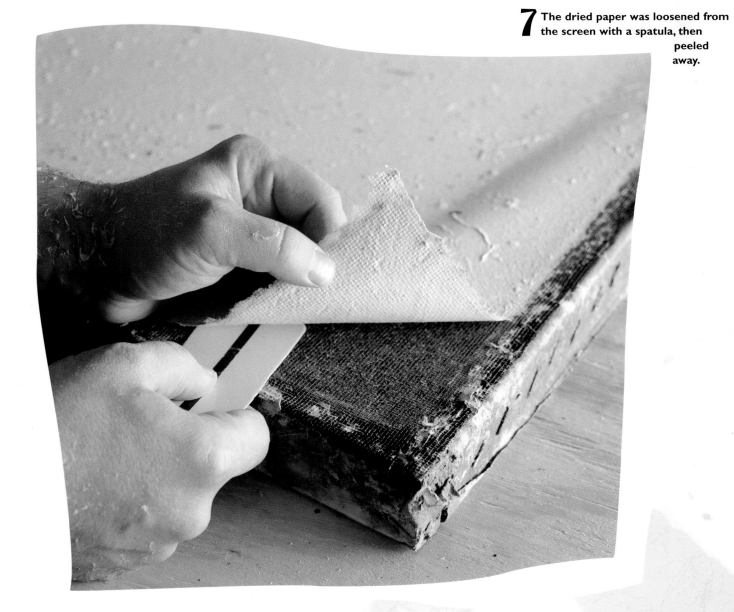

7 The dried paper was loosened from the screen with a spatula, then peeled away.

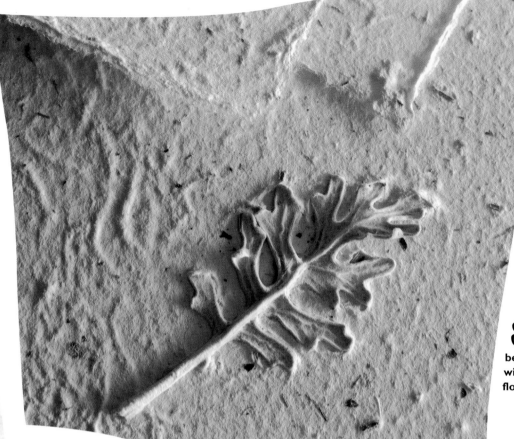

8 The finished paper is beautifully textured with pieces of the flowers and greenery.

Tips for great design with handmade paper:

Custom handmade paper can be made in any quantity and size; the key is to allow enough lead time for the paper to be made. Potash recommends allowing four to six weeks for this. His studio can create 500 to 1,000 sheets of paper per week.

Most anything fibrous—including many items from nature—can be made into paper; nonporous materials such as metals and plastics don't work well.

Common handmade paper can be found in art supply stores and runs anywhere from a few dollars per sheet to over $50 per sheet, depending on the size of sheet, quality, and where the paper was made.

Handmade paper is sturdy and can be letterpressed, engraved, silk-screened, offset printed, embossed, foil stamped and die-cut. Four-color photography also reproduces well on handmade paper, but do use some common sense. You may not want to reproduce some kinds of photographs—such as portraits of people—on handmade paper containing "chunky" ingredients.

When working with handmade paper, remember these unique papers are part of the design, not just a background for the ink.

Designing with handmade paper stretches creativity and adds another dimension to the design process. Unlike using commercial paper, where the design comes first, think about designing the client's custom paper as step one, then design the project to flow from there.

Do not overwhelm handmade paper with graphics and other design elements. Let the beauty of the paper shine.

Using handmade paper for every page of a booklet can be overkill. If there are a lot of pictures and text, it is usually more appropriate (not to mention less expensive) to use handmade paper for the cover and use traditional paper pages inside.

If you choose to offset print on handmade paper, make sure your printer is experienced with the material. Another option is to have the paper silkscreened. Contact your local screenprinter who prints clothing, wood or corrugated.

If possible, know the person who makes your handmade paper. Visit their operation and establish a relationship with them; they can provide invaluable ideas and advice.

Designing with Handmade Paper

Acurix Design Group When graphic designer Marc Shereck was asked to design a project using handmade paper to promote the Colorado Springs Parks and Recreation Department, he was immediately drawn to the possibility of sharing the city's unique history through the use of non-traditional materials. The resulting booklet, entitled "Then and Now," brings together Shereck's design expertise and the creative vision of Denise Sherwood, the graphic designer on the city's Parks and Recreation staff who spearheaded the project.

CREDITS
Client: Colorado Springs Parks and Recreation Department/ Colorado Springs, CO
Design Firm: Acurix Design Group/ Colorado Springs, CO
Designers: Marc Shereck, Denise Sherwood, Michael Lamb, Joseph Calkins
Copywriter: Joseph Calkins
Handmade Paper: Jerusalem Paperworks/ Omaha, NE
Quantity Produced: 2,400

The city of Colorado Springs was founded by General William Jackson Palmer. Mrs. Palmer suffered from a chronic illness, so on the advice of her doctor, General Palmer took her out west to a more agreeable climate. To cheer up his sick wife, Palmer wanted to bring the look and feel of the prestigious East Coast neighborhoods to the new city. He laid out a town with wide boulevards full of flower gardens and designed three large parks planted with trees and flowers in formal European style.

The "Then and Now" booklet has a sepia-colored, handmade paper cover. Pieces of flowers and greenery harvested from the city's gardens were used to make the handmade paper in order to translate Palmer's legacy into today's world. The booklet describes the history of the Parks and Recreation Department, with the flowers in the handmade paper letting the reader touch, feel and see the result of General Palmer's vision. The title and graphics are printed on the cover of the piece in yellow and brown ink, echoing the colors of the flowers embedded in the paper. A geometric symbol blind-embossed in the cover graphic is actually a tiny layout of the plaza in the city's Acacia Park. Inside the booklet, copy telling the story of the city's founding and the history of the city parks is printed in brown ink on traditional yellow paper flecked with colors that mimic the flowers in the cover paper. Hand-wrought, primitive graphics of the city's parks and gardens enhance the text. In order not to detract from the beauty of the handmade paper cover, the booklet is bound simply: saddle-stitched with two staples.

Shereck feels using the non-traditional handmade paper honestly captures the beauty and romance of Colorado Springs's parks and their unique history. "Then and Now" is a keepsake for Colorado Springs's residents and a tribute to General Palmer's foresight and great love.

Other design uses for handmade paper:

- Packaging
- Business cards
- Folders
- Invitations and announcements
- Folios
- Greeting cards
- Brochure covers
- Annual report covers
- Stationery

1 The designers chronicled their initial ideas for the booklet in a presentation for the Parks and Recreation Department, shown at left. Then, they began experimenting with the handmade paper. Shereck tried cutting it into different sizes and folding it. The 5" x 11" booklet size he ended up choosing is unique, yet easy to hold and read. Since the flowers and greenery were so visible in the paper, Shereck wanted the cover design to subtly enhance the paper's natural beauty. Shereck and co-designer Joe Calkins used "Blast," a script typeface, on the cover.

The graphic on the cover represents a layout of the city gardens. To add textural interest to the graphic, the design team decided to blind emboss a symbol in it—a symbol that is actually a tiny layout of the plaza in one of the city's parks. This symbol is repeated above the page numbers inside the brochure. Using just two colors for the cover let the beauty of the flowers in the paper shine and also saved on costs. The printer cut the paper and offset printed the covers. The printer also blind embossed the covers using a die guide provided by the design team. The designers chose to leave the paper edges rough because they showcased the handmade paper's texture.

2 For the body of the booklet, the designers chose yellow paper with confetti-like flecks to mimic the handmade paper cover and add color. The paper was also 100 percent recycled, to keep with the environmentally friendly theme of the piece. Hand-wrought graphics enhance the sensitive, warm style of the copy and lend a high-touch, low-tech feel to the piece. The copy and graphics were offset printed in brown ink on the yellow paper.

Design team members decided a clean, simple binding technique would be truest to the handmade paper and the booklet's design. After the piece was printed, the printer saddle-stitched the booklets using two small staples—a technique that created a sharp spine and that was virtually invisible in the cover's textured surface. The finished booklet's graphics, copy, binding and flower-filled handmade paper cover beautifully complement each other and showcase the impact non-traditional materials lend to a piece.

Gallery

Printed on an uncoated 80# cover stock, this offbeat brochure for a clothing store was run under water after assembly and then sundried in order to give the appearance of a sketchbook that has been affected by age and use. The photos were printed on 80# coated stock and taped into place with ordinary masking tape. Each of the 3,500 pieces cost $10.
Design Firm: Campbell Fisher Ditko Design

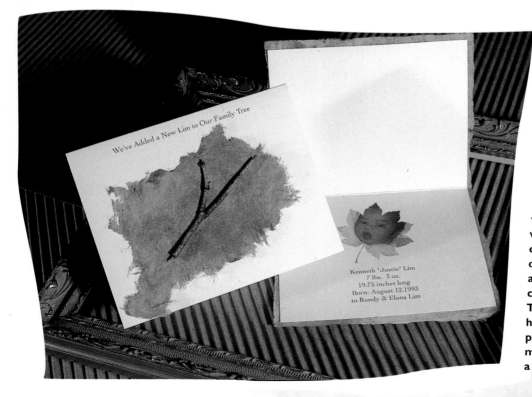

This birth announcement uses bark paper, produced in Mexico from indigenous trees and purchased at a local art supply store. Elmer's Glue was used to hold a twig on each cover. Two versions of the announcement were made: one with a full paper cover (as shown on the right) and one with a piece of bark paper applied to a more conventional cover stock (as shown on the left). The full bark paper version required hand-scoring and cost roughly $2.50 per unit. The other version could be machine scored; unit cost was under a dollar. Design Firm: Studio M D

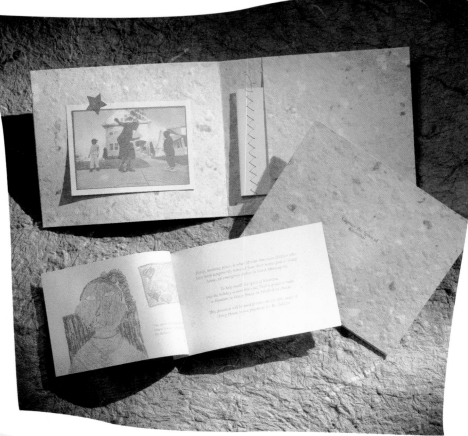

The contrast provided by the two paper stocks gives depth to this Kwanzaa greeting. The outside jacket is a stout, handmade cover stock, while the inner pages are a writing grade. One thousand cards were produced at a unit cost of $3. Design Firm: Shannon Designs

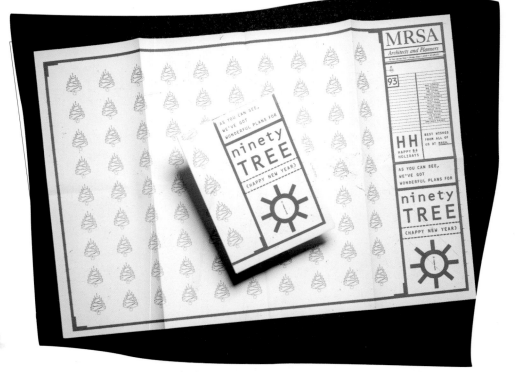

With the announcement that they have "wonderful plans for (the new year)," this New Year's greeting for an architectural firm is perfectly suited to the blueprint paper used. Design Firm: Segura Inc.

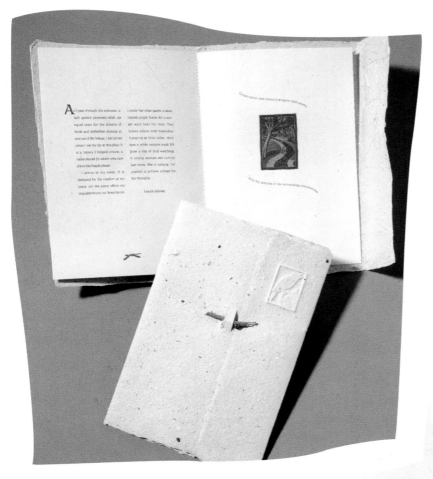

The cover for this brochure—promoting the development of an environmentally sensitive bed and breakfast—was hand-made from site earth and fibers, and was held closed with a piece of brush from the location. Two hundred brochures were produced at a unit cost of under $3. Design Firm: After Hours Creative

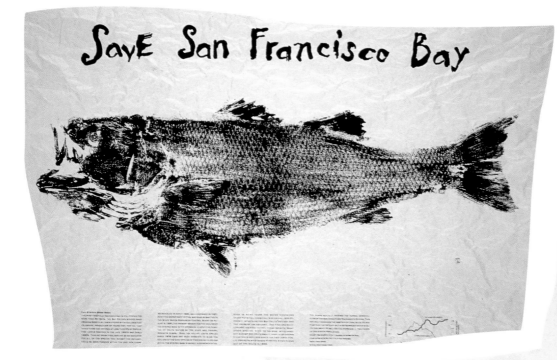

Ordinary newsprint paper was used for this poster for an AIGA chapter event, helping to keep costs to a minimum. Screen-printed in one color of ink, the poster was crinkled by hand after printing to enhance the fish/newspaper effect. Each poster cost one dollar; 300 were produced. Design Firm: Akagi Remington Design

This letterpressed wine list cover for the Napa Valley Grille is constructed from handmade paper consisting of natural fibers and the juice, seeds and skins of grapes. The pages are hand-bound with a stick tied into the spine with black cotton cord.
Design Firm:
THARP DID IT

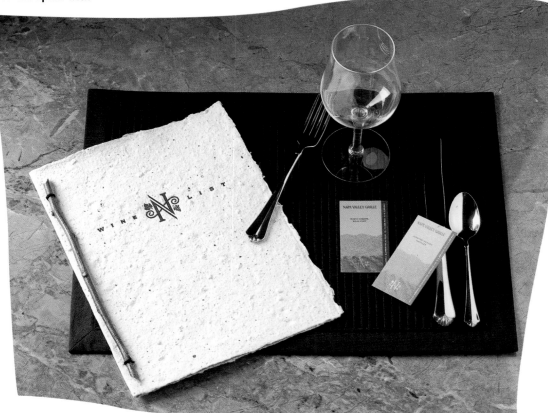

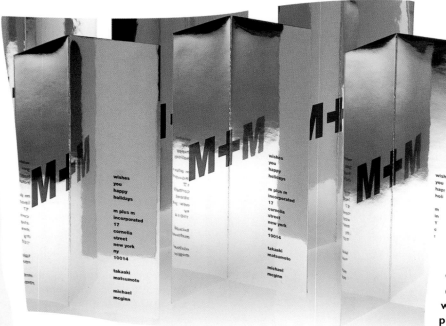

Mylar—a product with a mirrored surface—was used to create this three-dimensional holiday greeting. Only half of the company name (M+M) was printed on the paper; when folded, the mirror image completed the name. Design Firm: Matsumoto Incorporated

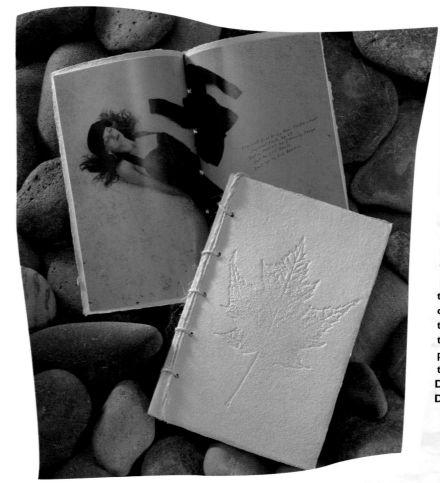

Three thousand of these direct mail pieces for Uh, Oh Clothing Boutique were produced at a unit cost of nearly $7. The leaf on the front cover was made by photocopying an actual leaf, then repeating the photo-copying process until a pos-terized version was created to make a debossing die. The piece was hand-bound with a three-foot piece of twine. **Design Firm: Campbell Fisher Ditko Design**

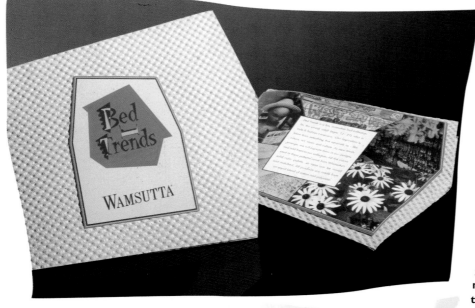

This brochure, developed to promote a line of bed linens, utilizes materials also used in the packaging of the product. A printed panel was glued to the cover of the brochure. Special attention was required to ensure the right amount of glue was used. Too little glue meant the piece wouldn't hold; too much and the glue was absorbed by the porous material, creating a stain on the other side. **Design Firm: Wamsutta**

This moving announcement is a blend of text printed on fine paper and "flysheets" made of packing material. It cost a total of $4,200 to produce 3,000 pieces. Design Firm: Segura Inc.

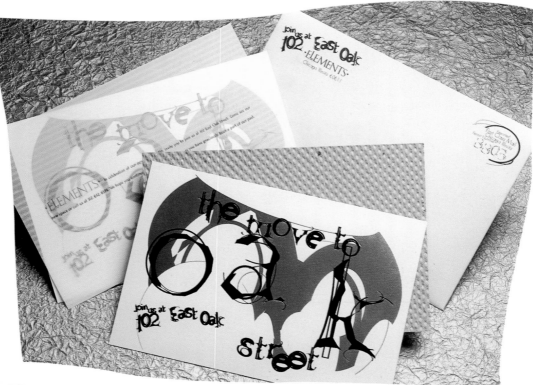

To create an invitation that would also be a souvenir, this piece was screen-printed on a product known as asparagus board. Typically used for absorbing moisture in asparagus boxes, this material is more readily available during harvest season. The asparagus board for this particular project was sourced out of Fresno, California. Design Firm: Mauk Design

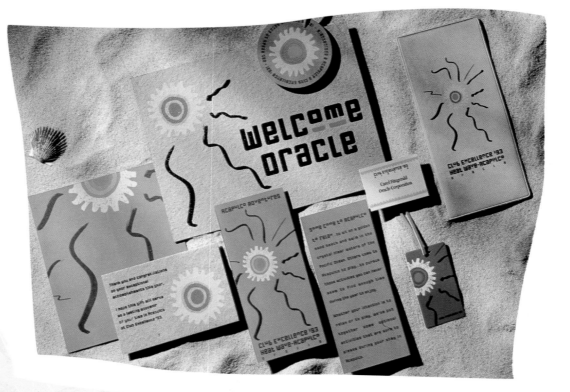

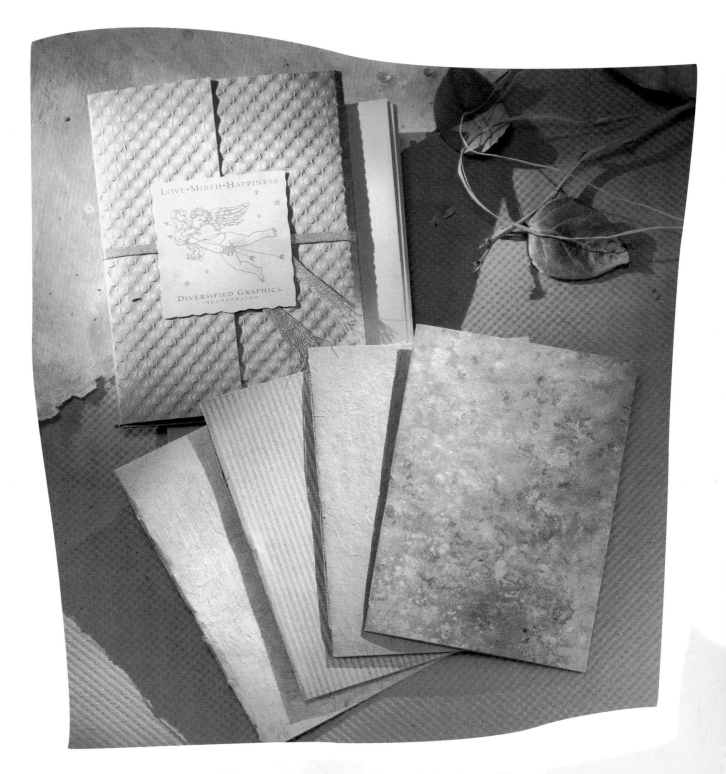

Various handmade specialty paper cards were pamphlet-stitched before being assembled into this printer's holiday promotion. While they are available in bulk quantities, such papers are often sold in single sheets at the retail level.
Design Firm: Shannon Designs

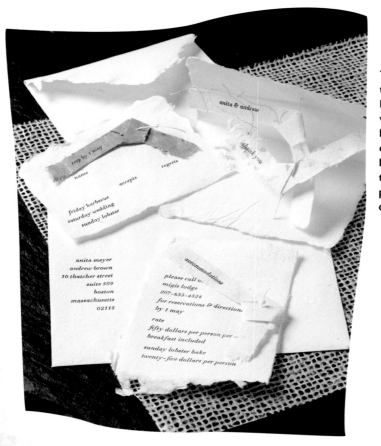

The papermaking, sewing, tearing, tying, gluing and all handwork for the invitation was done by the designer/ bride and friends, making it extremely labor-intensive, but also very personal. A total of 200 invitations were produced. Design Firm: plus design inc.

In keeping with the rural heritage of the state, this poster for an arts fair in Iowa is printed on a Kraft paper feedbag. Purchased from a local manufacturer, the bags were subsequently screen-printed and riveted in the upper right corner to allow the tag to be attached. The designer notes that the use of this particular non-traditional product allows the poster the opportunity to be three-dimensional. "Just stuff the bag with newspaper, staple the bottom, and you've got a free-standing display!" Design Firm: Sayles Graphic Design

48

Designing with Found Objects

plus design inc If designer Anita Meyer wants to remember a person or a place, she saves objects that capture a moment in time. When studying in Japan, she kept a basket inside the front door, and every day she emptied her purse into the basket.

CREDITS

Design Firm: plus
design inc/Boston
Client: The Getty
Center/ Santa
Monica, CA
Project Director: Julia
Bloomfield
Project Coordinator:
Stacy Miyagawa
Concept/Art Director:
Anita Meyer
Designers: Anita
Meyer, Jan Baker
Typographer:
Monotype
Composition Co./
Boston
Lettering: Jan Baker
Sewing: Cameo
Sportswear/Malden,
MA (poster);
Elissa Della-Piania
(brochure)
Collage: Anita Meyer,
Nicole Juen (both
pieces); Carolina
Senior, Veronica
Majlona, Jan
Baker, Matthew
Monk, Daniels
Printing Co.,
Stacy Miyagawa
(brochure only)
Papermaking: Jan
Baker, Rafael
Attias, Nicole
Jeun, Mookesh
Patel, Anita Meyer
(poster)
Printer: Aldus
Press/Malden, MA
Quantity Produced:
1,500 (poster);
2,000 (brochure)

Her resulting collection of receipts, notes, maps, matchbooks and other objects is a very powerful memory of her life at that time. The designer also communicates with others through these found objects. "I keep files on the time I spend with my friends and save pieces of paper—ticket stubs, cards, letters and other things. I made a wreath for a friend out of things from her file; it represented our history together." Meyer makes her own greeting cards, often including a button or other personal object because they reflect her personality better than anything printed on paper.

Meyer's philosophy of communicating with found objects also shows in plus design's work. When plus design created a poster for The Getty Center for the History of Art and the Humanities, Meyer and Jan Baker used found objects to communicate the Center's uniqueness, site and sense of purpose.

The Getty Center's goal is to bring together international scholars to re-examine the meaning of art and artifacts within past and present cultures. Plus design's poster announces the Getty Center's program of fellowships for scholars in the humanities and was mailed to academic institutions throughout the world.

For the poster, Meyer used a variety of techniques to bring the Getty Center to life. The Center's hand-lettered mission statement is printed in sand-colored ink on a white, grooved paper to form the poster's background. In its center, a collage of four squares reflects the defining elements of the program. One square is paper created from the Center's recycled documents. Pages from the Center's discarded books form a second square; the mission statement itself forms the third. The fourth square refers to the sea, sand and sky of the Center's spectacular site. The sewn purple lines represent a timeline and a sense of history. Text containing information on fellowships was created on the computer and offset printed in blue ink.

Meyer stresses that the budget for the Fellowship poster was the same as for previous four-color Getty Center posters. Because they felt so strongly about the found object concept, Meyer and her design team did a lot of the production work themselves and found innovative solutions—such as making their own paper—to keep costs down.

The Getty Center's brochure takes the poster's theme further. To express the Center's unique approach to the study of art history, a collage of objects representing the Center's mission, programming and location are sewn onto riblaid parchment paper. The parchment is printed with a hand-rendered mission statement and computer-generated type containing information about the Center's programs. The line of thread through the collage serves to link the Center's rich assemblage of resources and programs. The Center's business card inside a clear plastic bag of sand symbolizes the Center's ocean site. Library slips, scholar identification cards, pages from old Center newsletters, envelopes from foreign correspondence, pieces of filmstrips and white cotton gloves used to handle artifacts unfold before the recipients' eyes to create an impactful collage of The Getty Center's diversity.

The poster and brochure bring Meyer's and Baker's design philosophies to life and capture the essence of a unique institution. The found objects allow one to experience the Getty Center through touch, hearing, sight and smell—something that cannot be duplicated by a traditional printed piece.

1 Asked to design a poster for the **Getty Center**, designer Anita Meyer began brainstorming and making preliminary sketches. Her goal was to communicate the Center's uniqueness, site and sense of purpose to the viewer. Meyer presented two ideas to the client. One contained a collage of paper squares sewn onto the center of a square piece of heavy paper by two continuous lines of stitching, each square communicating a feature of the Center. The other idea was a long, narrow poster that accordion-folded and contained a row of sewn-on elements. The client loved both ideas and suggested the square piece become the Center's poster and the other an accordion-folded brochure. The poster, featuring letterpressed hand-made paper squares, was produced first, then the brochure was created.

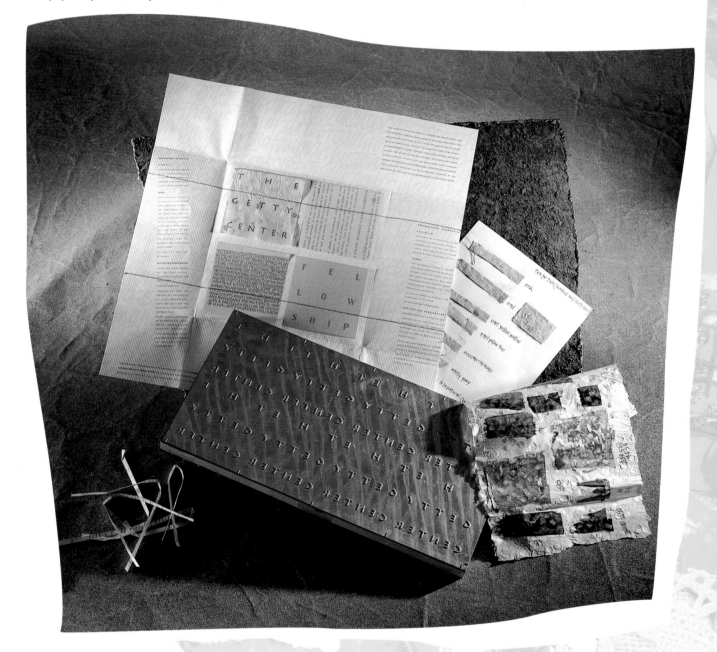

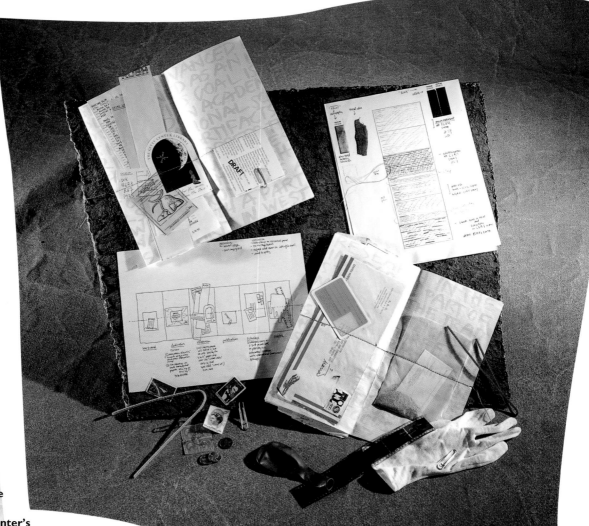

2 To gather materials for the brochure, Meyer visited the Getty Center's various departments and asked staff members to show her everyday objects that represent what they do. The designer spent some time brainstorming and looking at the materials she'd brought back from the Center to see which ones were feasible, both visually and practically. She made a list of items she'd like to use—including envelopes from foreign correspondence, pieces of filmstrips, and library slips—and the Getty Center created an "Action List" so employees could gather the correct materials in the amount needed.

By sewing different objects to parchment paper, Meyer made two prototypes, shown here, in order to experiment with the placement of the objects in the collage. The designer then made a final sketch of the brochure, also shown here, noting the objects to be included. Throughout the production process, the contents of the collage changed due to availability of the materials. Meyer and the client stayed flexible.

Other design uses for found objects:

- Posters
- Brochures
- Invitations
- Announcements
- Displays
- Photographic backgrounds
- Annual report covers
- Folders
- Stationery
- "Anything and everything," say Anita Meyer and Jan Baker

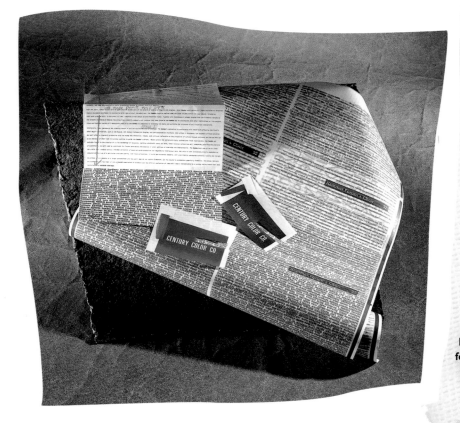

3 Designer Jan Baker hand-rendered type of the Getty Center's mission statement to be printed on the brochure. Meyer chose to print the brochure on parchment paper because she liked the transparent look—you can see the contrast between the modern type on one side and hand-rendered type on the other. Meyer did several typography studies for the computer-generated type that explains the Center's programs. She used two contemporary fonts to demonstrate the Getty Center's breadth. The designer sent a color summary to the client that showed type color and placement and thread color. The parchment paper was offset printed with the hand-lettering and computer-generated type, then hand-folded. Shown here are the press sheets for the brochures.

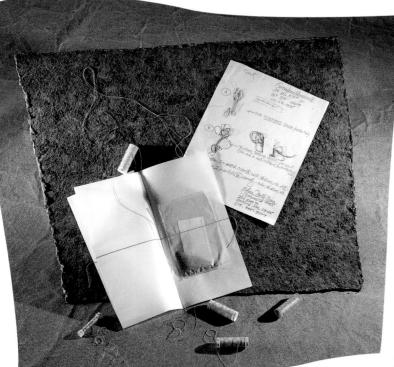

4 Meyer experimented with different threads to find out which type and color would look best and which could sew most easily through all the different materials in the collage for the brochure. She consulted a local costume designer, who recommended colors, weights and types of thread. The threads were tested by sewing objects on the paper; during the process silk thread was eliminated because it kept jamming in the sewing machine. Finally, a gold, satin-sheened 100 percent cotton thread was selected.

Tips for great design with found objects:

🐟 Usable found objects for your designs are all around you. Look for them when you're shopping, walking in your yard, cleaning your house, eating out, or doing just about anything. Save everything you find interesting and file it in an orderly way to use in future projects.

🐟 Projects using found objects need to be managed well, since there are so many details. Keep the process organized and efficient so the creativity can keep flowing, and always keep your time frame and budget in mind so the project doesn't get out of control.

🐟 If a specific object isn't available, be flexible. Some factors may be out of your control.

🐟 Using found objects in a piece requires a lot of time in sourcing and production. If possible, get the client involved and bring in other design team members. It helps both practically and creatively and makes the process and the results more interesting.

🐟 Found objects can be a challenge to bind into a piece, but be creative and experiment. Push your creativity to the limit; the client and your own instincts will tell you when you've gone too far.

🐟 Don't use found objects in a project just for the sake of using them. If they don't signify something, they're no more than a gimmick.

5 Each collage item was lightly taped in place with artist tape; the collages were then sewn down, and the artist tape was removed. The design team rubber-stamped selected items in the collage using actual stamps from the Center. An admissions ticket was tied on to the brochure with the gold thread. To carry through her found objects theme, Meyer chose to mail the piece in recycled interoffice envelopes from the Center. She mailed one to herself first to make sure the post office would accept them.

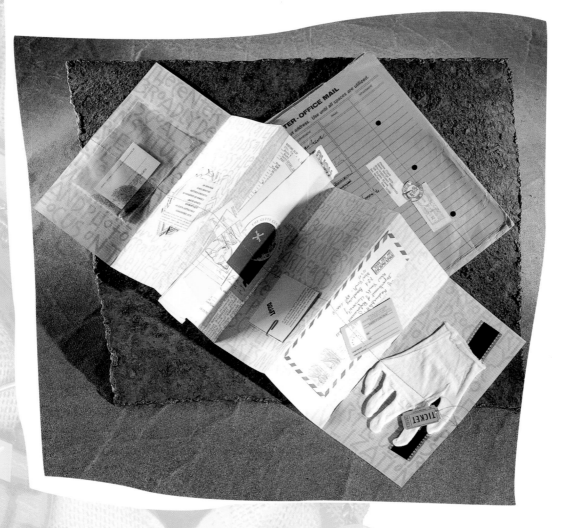

Gallery

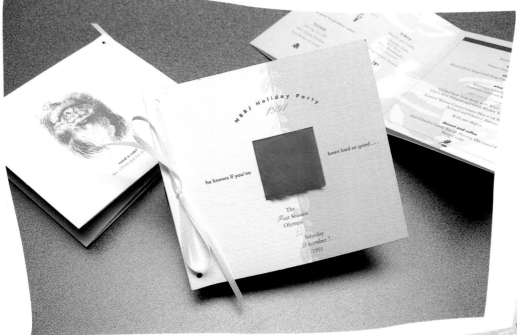

This "warm and fuzzy" party program revisits the days of believing in Santa. To make the program, a large piece of "Santa fur" was backed with double-sided tape and cut into small squares. A 20" piece of ribbon was used to finish the folded piece. Total project cost was $1,100 for 375 units. The designer said the only unanticipated production challenge came in cleaning up all the red fuzz after assembling the project. **Design Firm: NBBJ Graphic Design**

A hand-assembled, engraved booklet of quotations was bound with a corrugated spine, then wrapped in specialty paper, tied with raffia, and topped with silk roses for this wedding invitation. The entire package was then placed in die-cut, hand-assembled boxes for mailing. This project involves a number of traditional techniques, but also incorporates some unusual "found" materials. **Design Firm: Blue Sky Design**

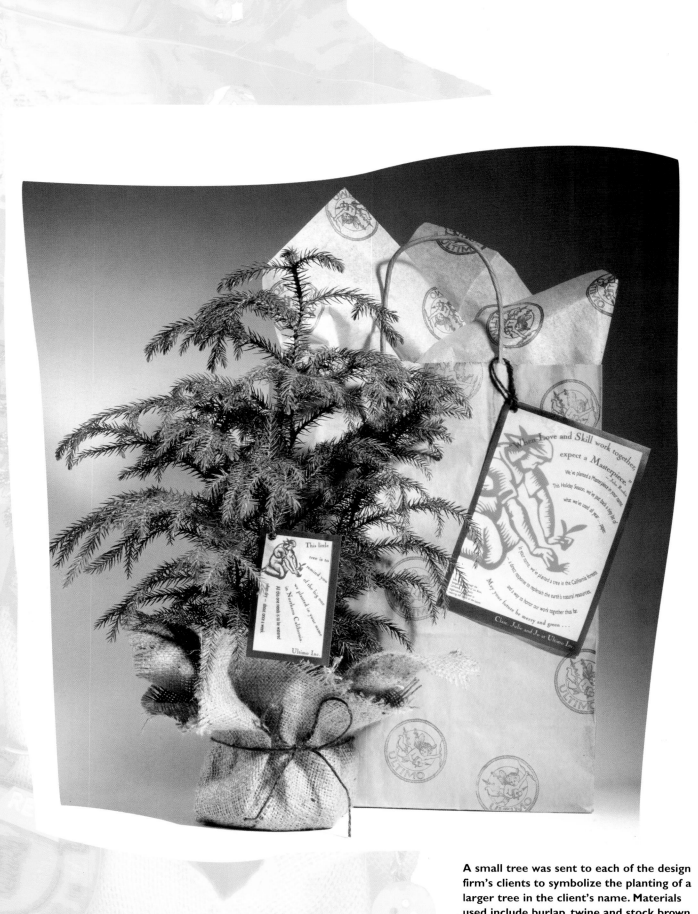

A small tree was sent to each of the design firm's clients to symbolize the planting of a larger tree in the client's name. Materials used include burlap, twine and stock brown handled bags. A rubber stamp was used to imprint the bags and tissue paper. Design Firm: Ultimo, Inc.

This invitation for a design firm's open house makes effective use of drywall left over from the construction of the studio. A rubber stamp—fashioned to mimic those used by architects—was used to "print" details of the event. **Design Firm: Hornall Anderson Design Work**

By using unconventional materials, this self-promotional brochure demonstrates the design firm's commitment to unusual design avenues. The cover is fashioned from leftover floor covering; the inside features microwave popcorn packaging, used chipboard mailers and misprinted letterhead. One hundred books were hand-bound using bookbinding tape and string. Cost per unit was about $3. **Design Firm: Studio M D**

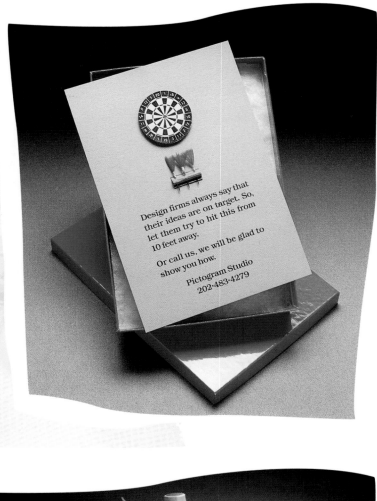

This self-promotion series for a visual communications firm makes creative use of items purchased from a miniatures dealer and stock boxes bought through a local box and label company. The miniatures were hand-glued to cover-stock cards bearing appropriate copy. Design Firm: Pictogram Studio

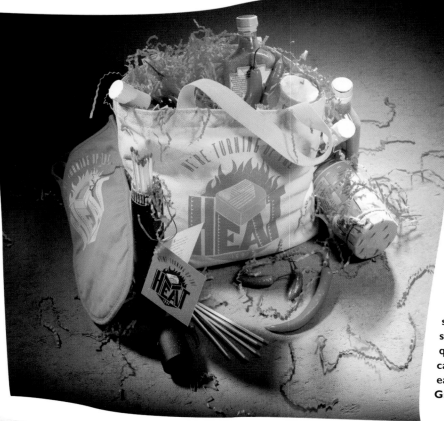

A custom-printed canvas totebag filled with products available at the retail level is used to produce a "hot" promotion for a sales conference. A coordinating oven mitt helps complete the thought. In small quantities, promotions such as these can be produced quickly and economically, and can be easily customized for each recipient. Design Firm: Grafik Communications Ltd.

A three-dimensional holiday greeting, the lightbulbs on the front appear to be simply a design element but turn out to be tied to the message inside. The boxes were assembled by hand and the design was output on a laser printer. Ten of the boxes were created at a cost of less than $30 total. Design Firm: Robert Padovano Design

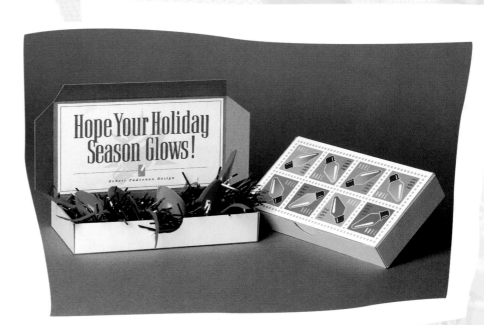

This personal pro-file/resume book uses old books, maps and rubber stamps to give it a very human feel. The tissue/ parchment paper was taken from an old receipt book given to the designer who says, "People think about me when they

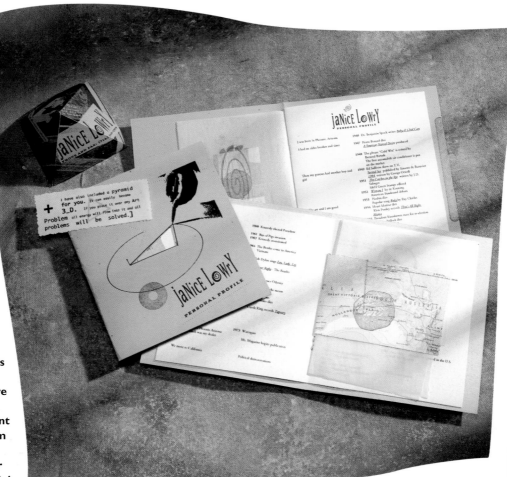

are throwing things out because they know I can use them in my work." Printing of the piece was done on a photocopier using computer-set type. The cost per unit was approximately 75 cents for 350 books. Design Firm: Modern Illustrations

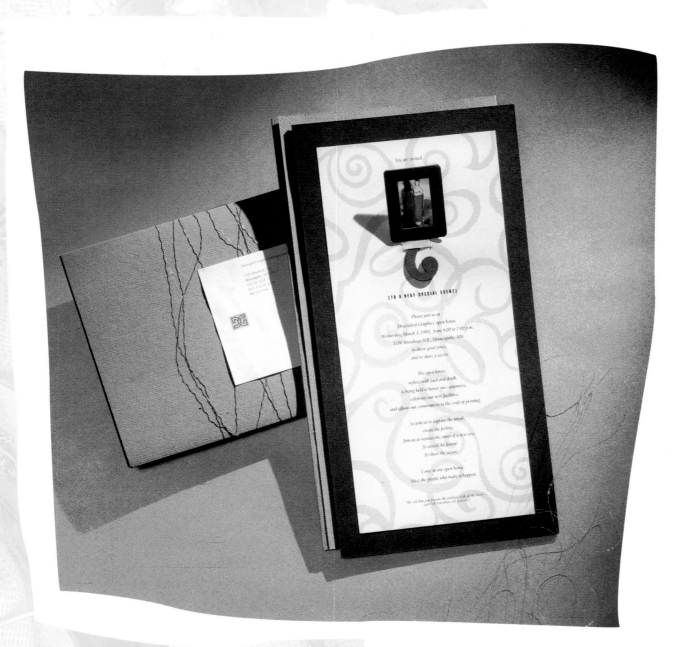

An invitation to an open house for a printer, this piece arrives in a custom wrap held closed with gold metal-like wire. The invitation itself is mounted on Letraset black board, which features two die-cut slits though which a custom-mounted 35mm slide is slipped. Eight hundred invitations were produced at a unit cost of approximately $2.70. **Design Firm: Shannon Designs**

This catalog for an exhibition was actually meant to be a part of the exhibit. Loose silk flower petals were inserted into each catalog to represent one of the artist's projects, and the book was tied closed with a ribbon threaded through die-cut slits in the cover. This was to facilitate keeping the petals in place. Design Firm: Matsumoto Incorporated

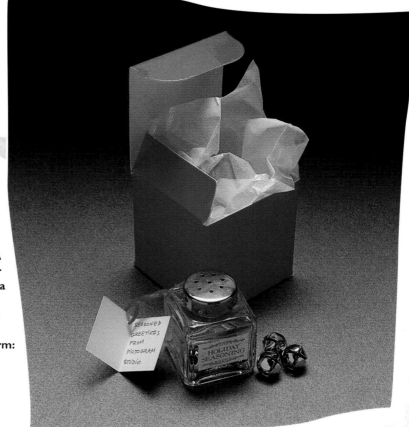

This holiday promotion, "Seasoned Greetings," is made entirely of stock items available on the retail level. A salt shaker is filled with silver jingle bells and inserted into a red enamel box. The label on the shaker and the note card are the only custom-made items in the piece. Design Firm: Pictogram Studio

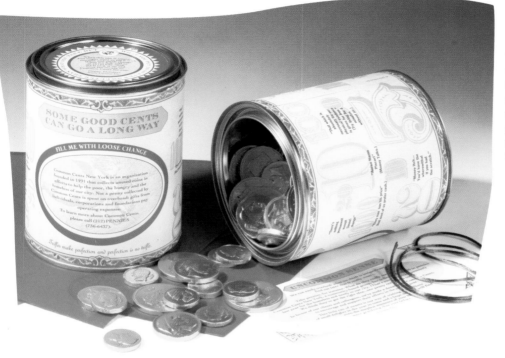

Quart-sized paint cans filled with candy coins symbolize the work of a New York charity, Common Cents. Recipients were urged to fill the cans with loose change and send it to the organization. Information about the charity appears on a hand-glued label placed on the can. Design Firm: Ultimo, Inc.

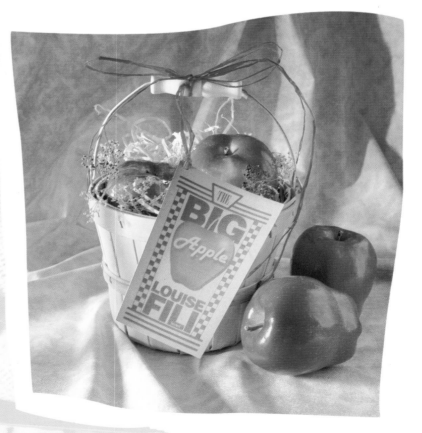

This targeted promotion was hand-delivered to Des Moines graphic designers, inviting them to come to a presentation by New York designer Louise Fili. Baskets and curled wood shavings, for packing, were purchased at a local craft store, completing the presentation of "Big Apples." Accompanying basket tags were printed using a dye-sublimation printer —a photo-quality print process ideal for short runs. Design Firm: Norgaard Graphic Design

Using "First Aid for Bad Design"
as his theme, this University of
Tennessee graduate developed a
unique letterhead and resume
ensemble. Fabric-type bandages
were imprinted using a rubber
stamp and hand-applied to each
different element in the identity
program. Designer: Sharp Emmons.

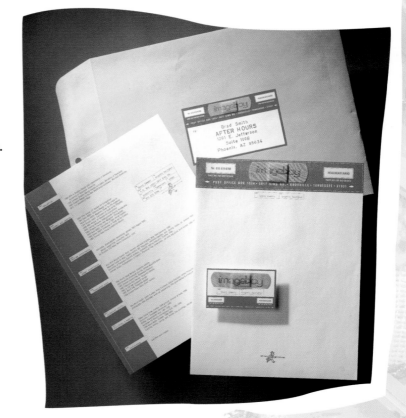

This exhibit invitation
utilizes a variety of mate-
rials, including corrugated
cardboard, high-density
foam, metal and powder-
coated wire grid. The grid
was custom-made to reflect
the grid-like quality of the
exhibit. The geometric
shapes are cut from high-
density foam and painted
with acrylic enamel. Hot glue
was used to bond individual components to each other. Design
Firm: Hornall Anderson Design Works

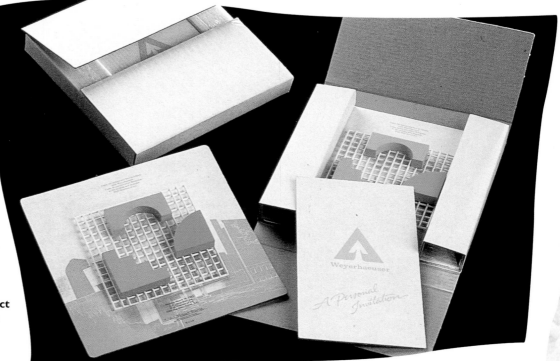

Seventy-five of these invitations were produced for a Minnesota marathon breakfast held in the fall. Printed invitations were placed in glassine envelopes; actual fall leaves were added to represent the tree-lined parkway athletes would run on during the 26-mile event. Design Firm: Shannon Designs

Designing with Acrylics

When Access Graphics, a wholesaler of high-end computer products, contacted Sayles Graphic Design about doing a direct mail announcement for a sales incentive program, designer John Sayles saw the opportunity to take a non-traditional approach and create a custom three-dimensional piece. The client had a tough sell ahead, and a paper announcement might not have the impact needed. Sayles's creative team came up with the theme "There's no time like the present to say you're second to none!" To tie in with this message, and to get the attention of the recipient, Sayles designed a working custom desk clock made of acrylic and metal.

CREDITS

Design Firm: Sayles Graphic Design/ Des Moines, IA

Client: Access Graphics/ Boulder, CO

Art Director/Designer: John Sayles

Copywriter: Wendy Lyons

Acrylic: Van Horn Plastics, Inc./ Des Moines, IA

Metal: Des Moines Ornamental Iron Company/ Des Moines, IA

Clock Mechanism: Ronell Clock Co./ Grants Pass, OR

Corrugated Box/Tray: Elwood Industries/ Chicago, IL

Screws: Kurtz Hardware/ Des Moines, IA

Screenprinter: Image Maker/ Des Moines, IA

Assembly: Sayles Graphic Design

Quantity Produced: 100

Sayles, like the industrial designers of the 1930s he admires, often designs with acrylic; he likes its clean, industrial look. Acrylics have the additional advantage of being durable (with thirty times the impact strength of glass), lightweight, and available in a wide range of thicknesses and colors. Acrylic is also easy to cut, engrave and screenprint. While glass would have been Sayles's first choice for the clock, it would not have survived the mail intact. Additionally, the project had a tight deadline—two weeks— and Lucite, the acrylic Sayles ended up using, was easily accessible through a local plastics company.

Sayles chose stainless steel for the clock's base for reasons of both form and function. The solid look of the metal is an attractive contrast to the clock's Lucite face, and it also provides a sturdy base for the whole piece. The selection of brass for the nuts that attach the clock to the base was also a design decision; since they show on the clock face, Sayles positioned them at 3 and 6 o'clock to counterbalance the client's logo screenprinted in gold at 9 and 12 o'clock. The entire effect is sleek and streamlined.

The face of the clock is made of $1/2$" thick clear Lucite. The company's logo and that of SunPics, a partner for this mailing, are screenprinted in gold ink on the clock face. The clock's hands are made of bright-colored Plexiglas—one hand is red and one is yellow. Against the clear clock face, the hands appear to be floating in the air—an interesting design feature.

Recipients of the Access Graphics clock are reminded of the company daily, whenever they glance at the time. They feel like the company has sent them a gift, not just another piece of paper to file or toss. Sayles says he feels like he's done his job if someone receives something he's designed in the mail and that person tells everyone, "Come see what I just got!"

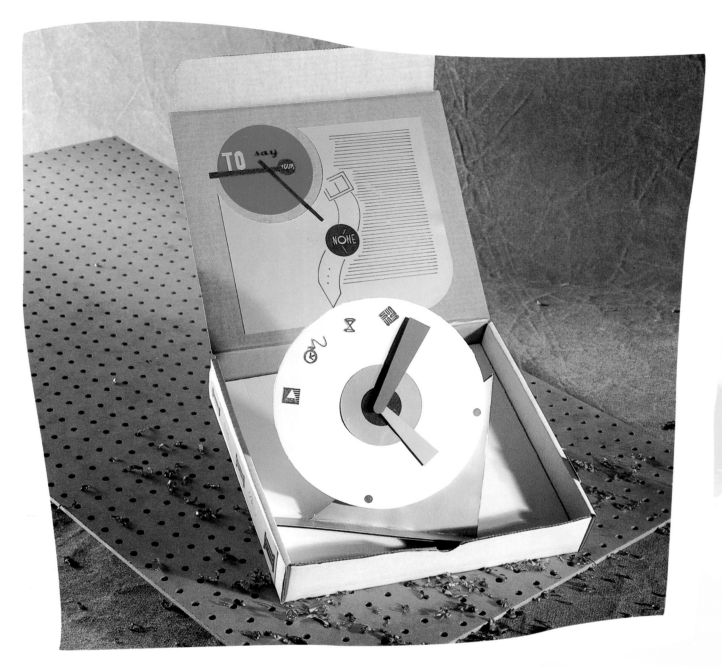

1 Sayles's first step in all three-dimensional projects is to draw up blueprints for the project to ensure all the suppliers involved can see how their material will be used and the exact dimensions needed. Sayles's blueprint for the project was a full-size, schematic drawing listing dimensions of the clock's elements and the materials to be used. A full-size drawing is best, but a scale version is more appropriate for a large piece. Working with this sort of concrete information allows suppliers to give accurate cost estimates for materials and labor; it also ensures that the ordered pieces will fit together when they arrive. Sayles then created this full-size model of the clock using foamboard and cut paper to sell the idea to the client. Two-inch samples of Plexiglas—in the colors to be used—were provided for the client to help them visualize the final piece.

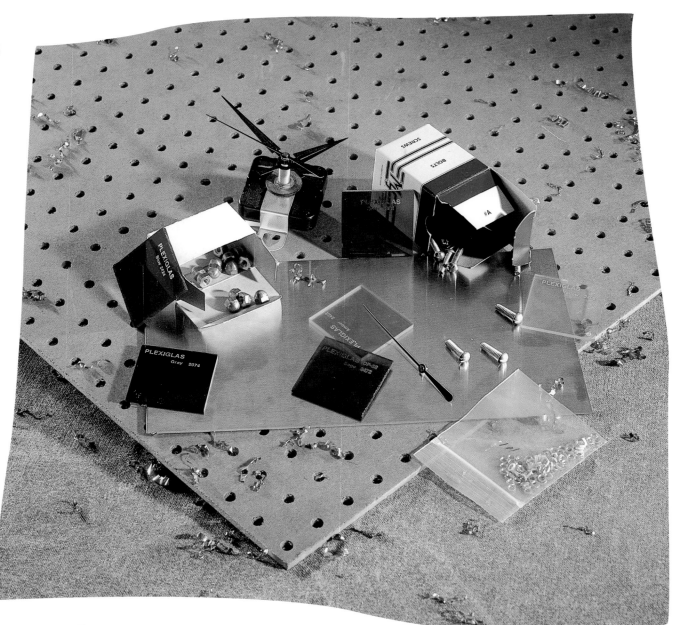

2 Once Sayles had the client's approval, he ordered standard corrugated boxes to mail the clocks in and had the boxes screenprinted while the other materials were in shipment. To make a prototype, Sayles gathered samples of all the materials he needed. He had the metal supplier fabricate one clock base, then used the base as a guide to have the acrylic vendor cut one clock face and a set of clock hands. Sayles originally found the prototype clock mechanism at a local crafts store. However, by looking through specialty catalogs, he was able to mail-order the rest of the mechanisms at a lower cost. The clock mechanisms came with stock hands, but Sayles chose to design Plexiglas hands to add to the clock's custom look.

In building his initial prototype for this project, Sayles discovered that the clock's metal base wasn't wide enough to support it. Sayles originally wanted to add a metal piece to the base to steady the clock. However, upon reviewing the clock's design with the metal suppliers, Sayles decided a clear Plexiglas "foot" would provide the needed support yet not detract from the clock's design. It was also easier to accomplish technically because the shape of the foot Sayles designed was easier and faster to cut from Plexiglas. A metal foot would have to be die-cut.

3 After he got the kinks in the prototype worked out, Sayles went in person to his suppliers, blueprint in hand, and ordered the rest of the acrylic and metal needed for the project.

Sayles first had the metal company make all the clock bases, using the blueprints as a guide; this took five days. Then he took the blueprints, the prototype clock base and a clock mechanism to the acrylic supplier, who cut the clock faces and hands and drilled the holes for the clock mechanism, hands and screws using the blueprints, base and mechanism as guides.

Before all the pieces were assembled, the clock faces were screenprinted with the companies' logos. Sayles contacted his screenprinter in advance to explain the project and reserve press time.

The screenprinting process was quick and easy—Sayles created film positives of the one-color art. Coarse screens and bold images were used for the art so the metallic gold ink would print evenly. Sayles's staff cleaned the metal and acrylic thoroughly, then assembled the clocks in-house because of the tight time frame. One hundred clocks took two people three days to assemble.

Tips for great design with acrylic:

≋ Acrylic shows fingerprints and scratches. Keep in mind how the finished piece is going to be used to determine if acrylic would be appropriate.

≋ When using clear acrylic, remember that flaws or imperfections in the materials used "behind" it will show. For example, Sayles had to make sure the Access Graphic clock's metal base was cleaned before it was attached to the clear Lucite face, since any fingerprints or dirt would show.

≋ A clear glue or bonding agent, like silicone, is best for acrylic, to avoid too much show-through of the glue at the joints or seams.

≋ Acrylics are generally available in 1/16" to 6" thicknesses. They are sold by the sheet—there are several standard sheet sizes, measured in inches—and by the square foot.

≋ The price and quality of acrylics are affected by the method used to manufacture them. The highest quality acrylics are produced by a cell-cast process where the material is cast between glass plates and then baked. The average cost of cell-cast acrylic is twenty cents per cubic inch. Less expensive acrylics are produced by the melt-calendaring process where the material is extruded from a machine and rolled between stainless steel belts under high temperatures. This type of acrylic averages twelve cents per cubic inch.

≋ Acrylics are available in several textures, opacities and colors. They can be cut, bent or molded into three-dimensional shapes.

≋ Acrylics can be cut with different edges—straight, beveled, and curved, for example. Edges can be matte or polished.

≋ As with other non-traditional material based projects, follow up with your vendors to check on the progress of your material orders. Keeping each supplier on time and on target is vital—a delay in one piece of the project may push back your delivery date.

Other design uses for acrylics:

- Displays
- Exhibit signage
- Portfolio covers
- Brochure covers
- Invitations
- Announcements
- Menu covers
- Display or presentation boxes
- Awards
- Table tents
- Desk accessories
- Furniture

4 To save time and money, the clock was mailed in standard corrugated boxes. Sayles designed a custom corrugated tray to hold the clock in the box. The box and tray were supplied by the same vendor. The die for the tray had already been cut when Sayles discovered the clock needed a Plexiglas foot. To accommodate the foot so the clocks fit in the trays, Sayles's assistant used the prototype as a guide to cut a slit in each tray. A personalized letter inside the box invited the recipient to sign up for the incentive program. The final screenprinted boxes are shown here.

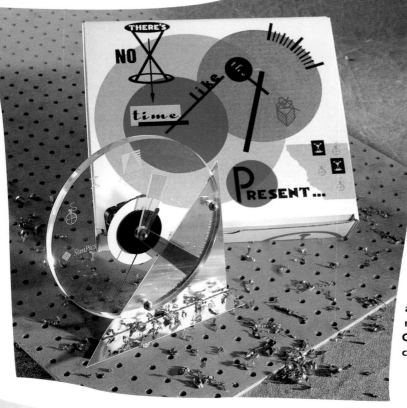

5 The finished clock generated attention and serves as a constant reminder of Access Graphics for the company's clients.

Gallery

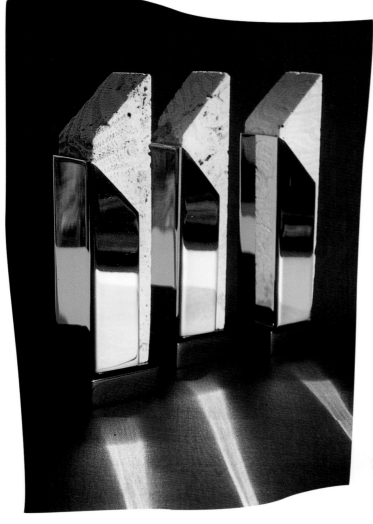

Fossilized coral rock was cut and shaped by a local sculptor to form the bulk of these design awards. The acrylic was cut to the proper size and shape, polished and then beveled along the top edges. The components are held together with an epoxy resin; a metal anchor runs through the base into the stone for extra sturdiness. Polished stainless steel was affixed to the keystone with epoxy. Three awards were produced at a unit cost of approximately $150. Design Firm: Blue Sky Design

The menu covers for an Italian restaurant in Hong Kong are made from a pliable plastic and bound with a clear acrylic dowel rod, which in turn is held in place with a small black rubber band. Twenty covers were made with a total project cost of 6,200 Hong Kong dollars (or approximately $800 U.S. dollars). Design Firm: Kan Tai-keung Design & Associates

This unique mailing for a packaging company becomes a miniature display unit when it is removed from the box. Aluminum and Plexiglas form the base of the piece to "display" the focal-point packaging options. The designer says the biggest challenge was finding the right adhesive to bond metal to acrylic; being non-porous, the metal had a tendency to pop off until the right product—a silicone epoxy—was located.
Design Firm: Sayles Graphic Design

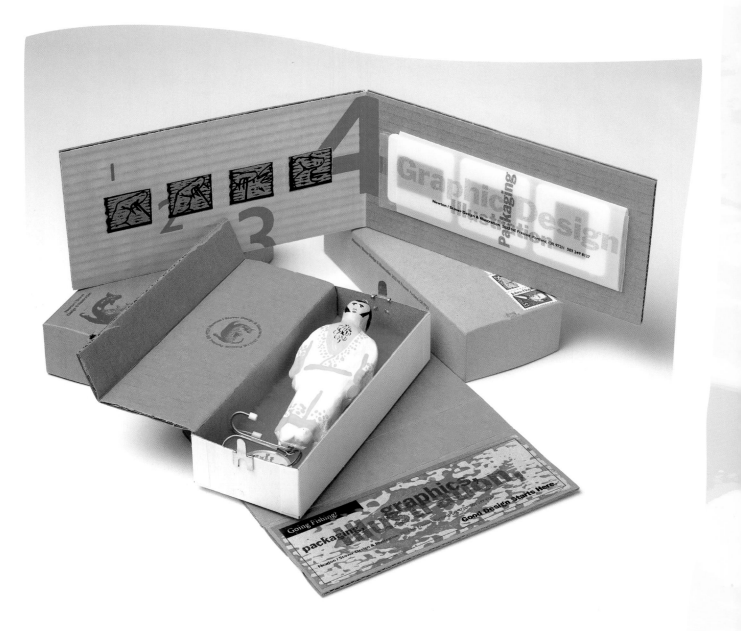

Wanting their first promotion to be one with a "hook," a Vancouver design firm developed an Elvis fishing lure as a limited edition mailing. A material called Super Sculpy was used to create the lure, which was then painted by hand and mailed in a standard corrugated box. A follow-up promotion, also shown here, explains the correct way to remove a fish hook from a finger. Design Firm: Newton/Stover Design & Illustration

A mailing to promote an upscale neighborhood development project, this piece features a custom pen set fabricated to suggest the project logo. Three colors of Avonite—a faux marble material—and two types of acrylic were used. Individual pieces were custom cut, screenprinted and finally assembled into the finished project. An epoxy adhesive holds everything securely in place. Design Firm: Sayles Graphic Design

Clear vinyl is used to its advantage in this invitation for an awards party held by Windows Magazine. Purchased in 4' x 8' sheets, each length of vinyl came with a protective film. Extreme care was required during screen printing and handling to avoid scratching the vinyl after the film was removed. The unit cost of each invitation was 70 cents; 3,000 were produced. Design Firm: Mauk Design

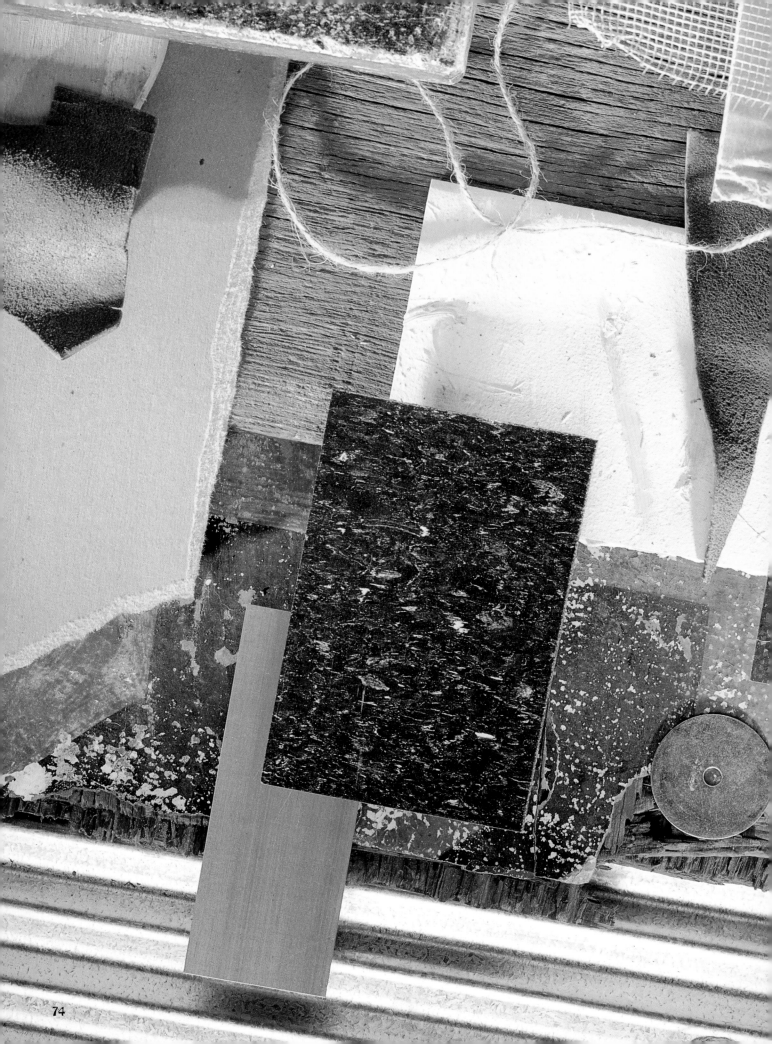

Designing with Glass

Designer Caroline Vaaler always keeps her eyes open. When she and her business partner, Cynthia Henry, spotted plastic, hollow fish mailers at a shop in Minneapolis, they contacted the manufacturer and ordered one hundred to use as a holiday thank-you gift to clients and as a promotion for their firm, Three Fish Design. The designers created notecards and placed them inside the fish, stuck address labels on them and sent them as thank-you notes. "Clients thought they were really great, but the Postal Service thought we were crazy," Vaaler laughs. Months later when she'd make a call, Vaaler noticed clients still had the fish. "I think that's when I realized non-traditional materials work," she says.

CREDITS

Design Firm/Client: Three Fish Design/Norfolk, VA

Designer: Caroline Vaaler

Glass/Materials: Merry-Go-Round Stained Glass/Virginia Beach, VA

Springs/Soldering Gun: Builders Square/Norfolk, VA

Shredded Paper: Gift Box Corporation of America/New York, NY

Corrugated Cardboard and Handmade Paper: Wyndstone Papers/Wheeling, IL

Quantity produced: 40

Three Fish Design uses a different non-traditional material each year for their fish. In the past several years, the firm has fashioned fish from matte board, clay, copper and canvas. Vaaler admits the fish ornaments give her a break from the computer and a chance to experiment with different techniques and materials.

The concept for her 1994 ornament grew out of a visit with her neighbor who does stained glass as a hobby. "I watched her patching a stained glass window, and I thought 'I could do that'," Vaaler says. Her friend spent an evening showing her basic glass-cutting techniques. "I learned by cutting fish out of some scraps of blue glass she had. They turned out pretty terrible," the designer laughs.

Despite her shaky initial attempts, Vaaler was hooked on the idea of using glass for her fish. Her friend recommended she visit a local stained glass store. Vaaler introduced herself to the store staff and immediately had a team of experts to help her.

Vaaler diligently applied herself to the learning process and made several attempts to create a fish shape. When the finished product emerged, Vaaler was pleased. "Even though the fish is a simple shape, the clear glass makes it something special and gives it the rustic and industrial look I was after," she says. The glass fish hangs by a tiny metal spring which she found on one of her hardware store "hunting" expeditions. "I love hardware stores," she says. "It's fun to

walk up and down the aisles and think of design applications for some of the weird little baubles and gadgets." When she discovered a bag of hardware springs in various sizes for a couple of dollars, she knew they'd provide the perfect finishing touch. "They were so whimsical," Vaaler says. She ended up with the perfect number of springs for her ornaments. "The springs add to the ornaments' industrial look, but don't detract from the streamlined design," she says.

Vaaler got the idea for the ornaments' packaging from a box pattern she'd seen in a magazine. In order to continue the fish's industrial feel, she used black corrugated cardboard. The ornament sits in a bed of shredded paper confetti. This serves the two-fold purpose of setting off the piece to its best effect and providing a cushion for the glass. Two bands of handmade paper wrap around the package and are secured with another small spring from the designer's cache. "The effect of the packaging is festive, but not the usual Christmas red and green," she points out. Vaaler hand delivered many of the ornaments. Those that were mailed were sent in envelopes lined with bubble wrap.

Vaaler says discovering new ways to use unusual materials in her designs is just one of the things she likes about creating her fish ornaments. "It's fun to use my hands, and every time I learn about a new technique, I grow as a designer. That's very rewarding."

1 Vaaler's first step was to figure out her "big idea" for the project. She sketched glass fish and packaging with various themes such as "Ice Fishing," etc. She soon realized that sending a fish ornament every year was a concept itself. The designer then sketched out some fish shapes that she thought would be appropriate for glass.

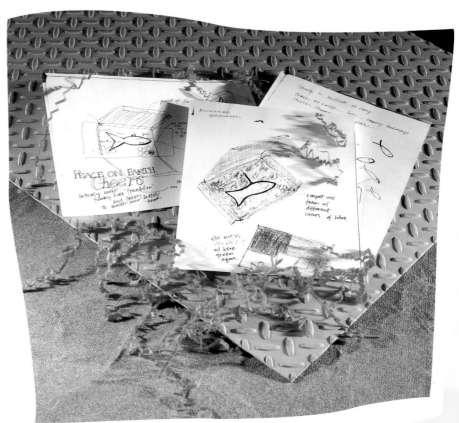

2 Vaaler's friend helped her experiment by cutting some blue glass she had on hand. During this initial experimentation, the designer realized that colored glass gave the fish a more "stained glass" look. She decided that clear glass would lend a more "industrial, fine art" feel to the project. It was also at this point that she discovered intricate patterns were hard to cut and very fragile.

The designer went to a local stained glass store to purchase supplies for her prototype fish. There were several weights and textures of glass. She bought five different kinds to experiment with.

Using a glass cutter she bought from the stained glass store, Vaaler cut twelve fish out of her glass samples. She laid her sketches under the glass to use as a pattern. One kind of glass, with large bubbles in it, was eliminated because it was too fragile. During this step, the designer simplified the shape of the fish because her original, more intricate ideas broke. She also discovered she liked the look of glass with smaller bubbles in it.

Next, she smoothed the edges of the fish with a metal file and then applied copper tape (also from the stained glass supply store) to the edges of the fish. She wasn't concerned with applying the copper tape perfectly because she wanted the fish to have a handmade quality. Vaaler burnished the copper tape with her thumb to make sure it would stay in place.

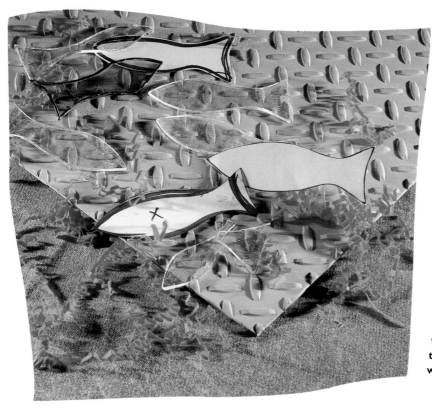

3 The next step was to solder the copper tape to the glass. First, the copper was cleaned so the solder would stick. (Solder resembles thick wire and is sold by the spool.) She purchased two different temperature soldering guns at a hardware store for about $12 each and found a medium temperature worked best for her project.

After the solder cooled, Vaaler discovered the copper tape had a backing that showed through the glass, and she didn't like the way the silver solder looked. She fixed this by rubbing a black patina on the copper tape and solder, giving the tape border a dark finish all around. She later discovered that the copper tape is also available with black backing.

After she washed each fish in soap and water, Vaaler used her coolest soldering gun to attach a loop of silver wire to the top of each fish. She attached a small metal spring to the loop as a hanger for the fish. Pleased with her prototype fish, Vaaler repeated the process to create forty fish in all. Glass for the fish cost $24; she spent $24 for two soldering guns, and one package of copper tape cost $6.40. The ornaments took two months, from conception to finished product, to complete. Vaaler researched and practiced the glass cutting technique for several weeks. Actually creating the final fish ornaments took about one week.

Tips for great design with glass:

🔷 Keep designs clean and simple. Intricate shapes are more fragile, and small pieces of glass are more likely to break off.

🔷 When working with glass or with any unfamiliar material, ask for advice from your vendors. They are the experts. Look in the phone book or library books on the subject for vendors to contact.

🔷 Glass is sold in stock sheets of various sizes, or the supplier can cut a piece of glass for you. Consult your supplier for how much glass to buy for your project.

🔷 Don't give up on an idea if the first type of glass you choose doesn't work the first time. There are many different thicknesses and textures of glass available. Experiment until you find the right one.

🔷 Since designing with glass is labor intensive, try to use the material in a project that will only be produced in a relatively small quantity unless you have a long time frame for production.

🔷 Always use safety equipment including goggles and gloves. Always smooth the edges of the glass with a metal file so your project can't be used as a deadly weapon. Cutting glass produces tiny splinters that can be dangerous. Be sure to clean up and vacuum your work area thoroughly.

🔷 Whenever possible, hand-deliver your glass project to the client; if it is to be mailed, pack it appropriately.

🔷 When working on a project with a small quantity, buy your materials retail. But when working on a larger project, buy materials wholesale; this may involve research, but it can be as simple as going to a retail shop to source material, then contacting the manufacturer directly.

🔷 Buy more materials than you think you need and save the leftovers for other projects.

4 Vaaler wanted the ornaments' packaging to echo the streamlined design of the fish, so she decided to use corrugated cardboard. After researching and experimenting with a few different styles—including the typical kraft color—she settled on black corrugated purchased from an art supply store. Two 32" x 38" sheets cost $25. Vaaler sketched some ideas for the package's shape, but then she found a gift box pattern in a magazine. Double-stick tape held the packaging closed.

Vaaler ordered red paper confetti from a specialty supplier, the Gift Box Corporation. The bands that wrap around the package were made from handmade paper from the art store at a cost of $14. Vaaler experimented with different colors and widths of bands for practicality and visual impact. The bands also lend a "holiday present" feel to the packaging. Another metal spring holds the belly bands together.

Other design uses for glass:

- Invitations
- Announcements
- Greeting cards
- Brochures
- Custom gift objects
- Awards
- Direct mail promotions

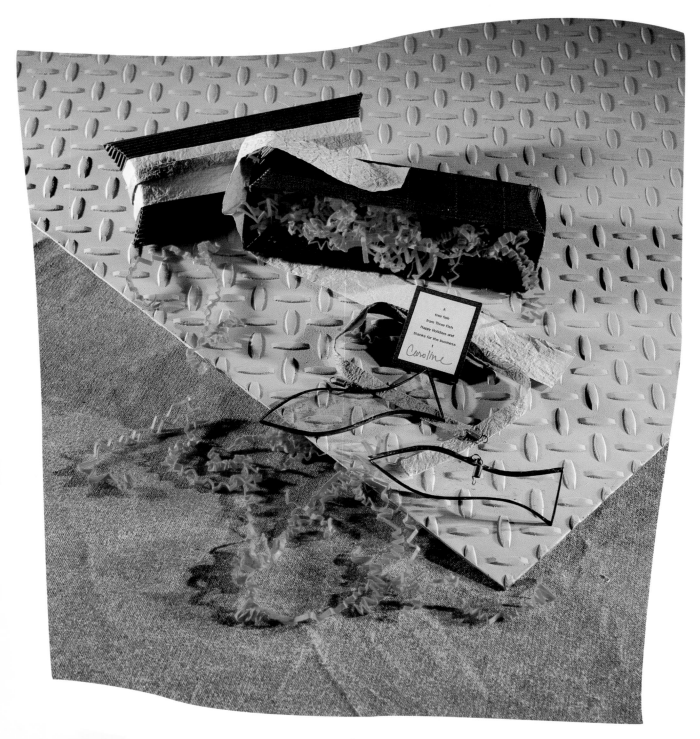

5 As a final touch, Vaaler laser printed a holiday greeting on paper and glued it to a square of the black corrugated for a gift tag.

Designing with Mixed Media

Sam Zell thinks big. As founder of Equity Group Investments, a Chicago-based commercial real estate empire, Zell is known for innovation and leadership in the business world. Zell has also become famous for something else—a holiday message in the form of a custom-made gift he sends to 650 friends and business associates. Custom surfboards and specially-commissioned paintings are the kinds of gifts commonly bestowed to lucky recipients. "Movers and shakers" worldwide have started collecting Zell's gifts; one even built a special display case to show them off. They have become more than just presents; they're a recognized symbol of prestige, representing membership in the tycoon's inner circle.

CREDITS

Design Firm/Client:
Equity Group
Investments Inc./
Chicago, IL
Executive Creative
Director: Sam Zell
Project Director: Peter
Szollosi
Consultants:
Peter DeSantiago;
Mark Weiner,
Pennington Promo-
tions/Chicago, IL
Sculpture: Michael
Speaker/ Portland,
OR (design):
Creative Model
Services/Chicago,
IL (production)
Woodcraft: Interior
Specialties/Chicago
Plaque: Rudy Backart/
Chicago, IL
(design); Trade-
Mark Designs/
Minster, OH
(production)
Box and Brochure
Design: Kevin Putz,
Toolbox, Inc.;
David Cisco/
Chicago
Boxes, Screenprinting:
Elwood Industries/
Cicero, IL
Specialty Electronics:
Ron Nudoll,
Accurate Sound
Corporation/
Menlo Park, CA

Zell and Peter Szollosi, the creative director of Equity Group Investments, usually start brainstorming on the annual project in October. When the two met in October 1994, Zell already had an idea. In 1990, he had made a speech to real estate leaders telling them if their companies could stay alive until 1995 they'd be assured of continued success. Thus, "Stayin' Alive 'til '95" became the big idea of the holiday piece. Zell had always been moved by the statue commemorating America's victory at Iwo Jima during World War II, and he wanted his holiday gift to be inspired by the statue's imagery of soldiers raising a flag. For a unique twist, the pair decided the piece should play music to further evoke the recipient's emotion. So Zell and a writer rewrote the lyrics to the Bee Gee's song "Stayin' Alive" to reflect Zell's 1990 speech and hired studio musicians and singers to record it.

Zell and Szollosi had three goals: They wanted the gift to be interactive, to give an appropriate message, and to be a keepsake that would be proudly displayed. Because of the unique idea behind the piece—particularly the song—there was the danger of the piece looking "hokey." Szollosi knew that the secret to the gift's success was in the execution—to use only quality materials and to hire suppliers who were problem-solvers and who could offer impeccable craftsmanship executed within his tight time frame.

A polyurethane sculpture of men raising a tall building sits on a wooden base, which bears a commemorative plaque and houses a cassette tape player. Wood buttons on the side of the base switch on the taped song "Stayin' Alive in '95." The gift is presented with a brochure featuring patriotic graphics and the words to the song; operating instructions are also included. The piece is nestled inside a velvet-covered foam bed inside the box, which presents the gift attractively and protects it during shipping. The whole package is mailed in a white corrugated box printed with red and blue stars.

Szollosi reports that recipients of the piece are speechless with appreciation. "They have never seen anything like it," he says. Zell and Szollosi are equally thrilled with the finished product. Their only concern? "How are we going to top this next year?" Szollosi laughs.

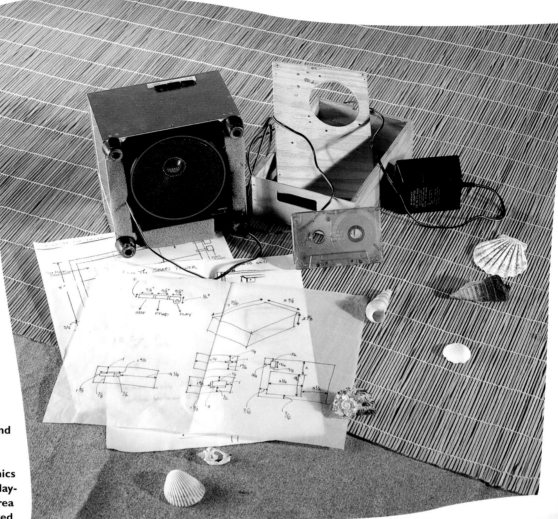

1 Three months before the product was scheduled to be mailed, Peter Szollosi and Sam Zell met and developed a concept and sketches of the design for the project.

Developing electronics for the cassette tape player was an unfamiliar area for Szollosi, so he started the production process by searching nationwide for a supplier. He discovered Accurate Sound Corporation in Menlo Park, California, a specialty electronics company that builds equipment for the recording industry. Szollosi met with Accurate Sound's president, Ron Nudoll, to explain the project; then Nudoll spent a few weeks developing prototypes of the tape player. The final prototype shown here included a custom amplifier and rechargable batteries. The tape player's volume would be set at one level, and the tape would be permanently affixed inside the player.

While Nudoll was developing the electronics, Zell and a writer wrote the lyrics to the "Stayin' Alive in '95" song. "Bee-Gees-sounding" singers were auditioned for the vocals and studio musicians were hired; Szollosi was even able to hire the original bass player from the Bee Gees's soundtrack. Recording the music and vocal tracks took two days.

To add a personal touch to the gift, Zell himself spoke some of the lyrics at the end of the song. A sound crew was brought to Equity's headquarters to record Zell's part. When the tape was complete, Szollosi sent it to Nudoll to test in the prototype electronics.

Common combinations of mixed media:

- Acrylic and metal
- Acrylic and wood
- Textiles and chipboard
- Corrugated and chipboard
- Handmade paper and textiles
- Handmade paper and unique bindings
- Found objects and corrugated
- Found objects and chipboard
- Found objects and handmade paper

2 Szollosi met with sculptor Michael Speaker to toss around ideas for the sculpture. Speaker did preliminary sketches of men raising a building in the same manner of the Iwo Jima statue; Szollosi and Speaker knew they had to be careful not to seem to be making fun of a battle where Americans lost their lives. The final, approved sketch shown here suggested a social commentary, similar to a political cartoon.

Speaker made a clay model of the sketch (shown bottom left in the photograph at left) and Szollosi brought it back with him to Chicago. Project director Szollosi took the clay model to Creative Model Services in Chicago, a company that does sculpture reproductions for museums and movie sets. Szollosi interviewed the company's Roman Haliziw and explained the project to him. He then put Speaker and Haliziw in touch so sculptor and caster could interact during the casting process.

Haliziw created a mold from the model; then Creative Model Services cast each piece—the men, the building and the base—separately in polyurethane. Since the plastic comes out of the mold pink in color, each piece was painted bronze. The sculpture was then glued together with a compound of CA cement and baking soda. The final result is shown bottom right.

3 While the sculpture was being created, Szollosi met with Interior Specialties—a company that builds furniture—about the wood bases. The company built him prototypes in different sizes and woods, and by the fifth one, Szollosi had what he wanted.

Interior Specialties built the bases from walnut, then sprayed the wood with a vinyl sealer to give a richer walnut color. The sealer was allowed to dry for six to eight hours; then the wood was sanded, cleaned and lacquered.

Szollosi approved the electronics prototype, then shipped the bases to Accurate Sound. Nudoll mounted the electronics inside the bases with Velcro and shipped them back. Szollosi commissioned the custom-etched brass plaque shown here for the front of the base. The letters and lines on the plaque were purposely rough to complement the sculpture's rugged look; copy on the plaque commemorates Zell's 1990 speech. The plaque was mounted with double-stick tape. To make the piece more personal, each plaque was numbered and a card containing information about the sculptor was included. Interior Specialties mounted the sculptures to the bases with the CA cement compound.

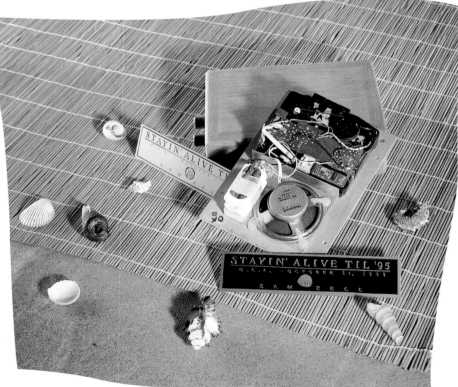

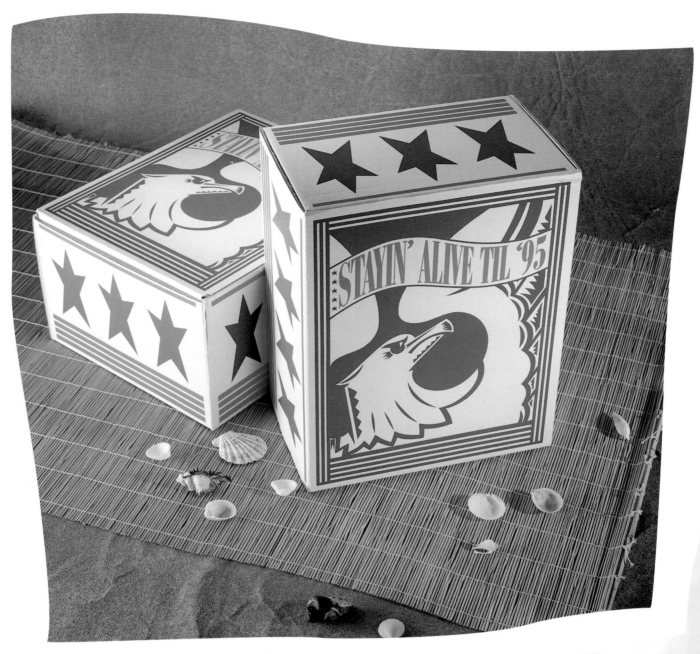

4 Szollosi sent the project's dimensions to Elwood Industries, who designed custom boxes. Szollosi hired designers David Cisco and Kevin Putz to develop a graphic theme for the box. The designers mocked up a box with graphics of stars to symbolize the flag of Chicago and an illustration reminiscent of a WPA-style stamp. Szollosi approved the concept. Elwood Industries screen-printed the boxes, shown here. The two designers also created the graphics for the song lyrics brochure, which was then offset printed. To present the piece attractively and protect it during shipping, a foam tray was die-cut by Adam's Foam Company, using a prototype as a guide. Velvet was airpressed to the foam using a hot melt adhesive.

Design uses for mixed media:

- ℮ Brochures
- ℮ Annual reports
- ℮ Invitations
- ℮ Announcements
- ℮ Awards
- ℮ Menus
- ℮ Direct mail promotions

Tips for great design with mixed media:

🖟 Let your idea be king; don't let convention determine how you bring it to life. Be off the wall.

🖟 Be specific with your vision. Give clear directions to your vendors. Meet with them and learn their language. Do your homework.

🖟 Request examples of your vendors' work to make sure they are capable of producing the caliber of product you need. Challenge them to rise above the ordinary.

🖟 Ask for and listen to your vendors' advice. They are the experts.

🖟 Murphy's Law—"If something can go wrong, it will"—was invented for mixed media design projects. Never get so comfortable with the process that you neglect to follow-up with your suppliers and keep them on track. Plan plenty of production time to allow for the unexpected.

🖟 If you're unsure about how a piece will hold up in shipping, mail the first one to yourself to check for problems.

5 One week before the shipping date, the unthinkable happened. While Szollosi's team was trying out each piece to make sure it worked properly, they discovered that the cassette players were destroying the tapes, the batteries weren't charged, and the wrong adapter cords for the cassette players had been sent. After many frantic phone calls, Szollosi was able to hire an audio engineer to reset the volume and speed of the tapes. Other team members charged the batteries and Szollosi found new adapter cords. The final finished piece shown here represents a true team effort of experts from many different fields and symbolizes the unique style of a legendary Chicago businessman.

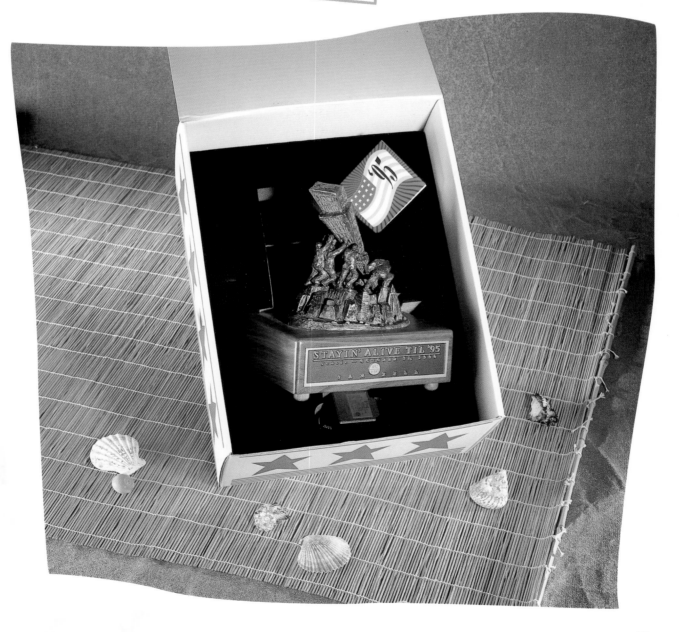

Designing with Textiles

Gregg Palazzolo likes the thrill of the hunt. When it comes to sourcing non-traditional materials for his design projects, anything is fair game. He's crawled through garbage dumpsters, is a regular at his local hardware store and recently, while renovating an old, abandoned grange building for his design studio, he saved the leftover construction materials to use in his designs.

CREDITS

Design Firm/Client: Palazzolo Design Studio/Ada, MI

Art Director: Gregg Palazzolo

Designers: Mark Siciliano, Kelly TerHaar, John Ferin

Photographer: Todd Zawistowki

Coconut Husk Material: Blocksom & Co./ Michigan City, IN

Printing: Etheridge Lithography/ Grand Rapids, MI

Imaging: Modern Imaging/Grand Rapids, MI

Japanese Paper: Bradley Printing/Des Plaines, IL

Brass Disks: Seton Name Plate Company/New Haven, CT

Quantity Produced: 250

When Palazzolo Design Studio was asked to create a brochure for a bedding manufacturer, the designer took a tour of the client's facility. During the tour, he came across a stack of a unique material resembling sheets of dried brown grass. Palazzolo asked his client what it was and learned the material was made of dried coconut husks; it's used in the substructure of mattresses, and it's never seen by the consumer. The designer begged his client to tell him where he could get some, and the client gave him a name and address.

Palazzolo decided he wanted to use the coconut husk material in the bedding manufacturer's brochure, so he called the company that makes the material. They couldn't figure out why a designer wanted the material, and thus were not very cooperative—but Palazzolo was persistent. He asked for other sources of the coconut husk and, after many phone calls, was able to obtain samples of the material.

The designer developed a prototype brochure for the bedding manufacturer which featured a coconut husk cover, but the client didn't like it, and didn't want to take the risk.

Palazzolo still liked the idea, so he decided to create a self-promotion with the coconut husk material. The result is a truly innovative booklet called "Textural Studies." The booklet presents the basic elements of design through black-and-white photos and key words such as "harmonious," "congruency" and "logic." "I wanted to help people understand what we do so they're not intimated by our work," the designer explains. The piece promotes the studio in the subtlest of ways. Todd Zawistowki, Palazzolo's cousin and a professional photographer, agreed to let the designer use photographs from his portfolio in the booklet, and in turn was able to use the brochure to promote his photography.

The coconut husk cover is a natural, tactile lead-in to the piece. The material is mounted on a single-wall corrugated folder, six inches square. The fly sheet inside the cover is a Japanese paper called Ogura #2. The brown, fibrous paper mimics the coconut husk in color and texture. Small black-and-white photos and descriptive words are printed on white, coated paper. The booklet is bound with two silver rivets, and a brass tag stamped with the initials "PZ" for Palazzolo Design Studio and Zawfoto (the name of his cousin's studio) hangs from the bound edge of the booklet by a piece of telephone wire.

The booklet mails in a stock corrugated box—a white box turned "inside out" so the brown side shows—with Palazzolo Design Studio's custom "stamps" adhered to it. Shredded paper scraps recycled from the firm's everyday mail cushion the booklet inside the box.

The "Textural Studies" booklet embodies Palazzolo's design philosophy: "If it's a great idea, do it until somebody buys it. If nobody wants to buy it, do it anyway."

1 Palazzolo took a tour of a bedding manufacturer and spotted a unique textile made from coco-nut husks, a material used in the substructure of mattresses. The designer got the name of a material supplier and contacted them. The supplier was unable to help, but referred him to other sources. After many phone calls over several months, Palazzolo obtained samples of the coconut husk textile, called Coirtex. The textile was too fragile to use alone as a booklet cover, so as a subcover, the designer used single-wall, C flute corrugated purchased from his local paper company. He cut the corrugated into 6" x 18" strips and the coconut husk textile into 5" squares using an X-Acto knife.

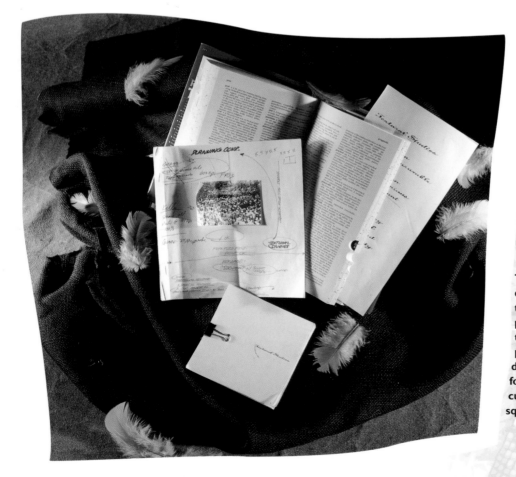

2 Palazzolo and Todd Zawistowski, the photographer of the piece, used a thesaurus to make a list of words that described design elements and matched photos to the words they selected. The designer wanted a "rough" look for the booklet's typography. He started playing with fonts and distortion filters on the computer. Using Adobe Illustrator, he selected Lino-Script font and used the Roughen and Tweak filters to give the type a hand-drawn look, then laser printed the type in-house. Palazzolo had the photographs scanned for position, then the booklet's pages were offset printed on coated white paper. The designer ordered the Japanese paper for the fly sheet through a catalog, and cut the paper himself into 6" x 6" squares.

3 Throughout the production process, Palazzolo experimented with different types of bindings. He originally considered using a conventional wire-o binding, but decided he wanted something that looked more handmade. He went to the hardware store and came back with rivets of different sizes and tried attaching various rivets to the corrugated until he found a size that held the booklet securely and looked good.

The coconut husk material could not be printed, so in order to identify the piece as Palazzolo Design's, the designer wanted to attach a tag to it. He discovered the perfect thing in a unique catalog by Seton Name Plate Company—1 1/2" brass disks used to tag industrial piping. Palazzolo used the embossing kits that came with the disks to emboss "PZ" on each disk by hand.

At the time this project was being developed, the designer was renovating an old 4,500 square foot Grange Hall—a place farmers used to hold meetings and socialize—for his design studio and found himself inspired by all the construction materials lying around. Accordingly, he decided to use rings of copper grounding wire and pieces of telephone wire to attach the disks to the booklet.

Tips for great design with textiles:

≈ Keep your eyes open. Unique textiles are all around you. Look at the carpet on the floor, the drapes at the window, the upholstery of the chair you're sitting on and the clothes you're wearing. Ask yourself, "How can I use textiles in my next design project?"

≈ To source an uncommon textile like the coconut husk material, think about its mainstream users. Contact them and ask for supplier information.

≈ When you talk to a textile supplier, use layman's terms. Don't be afraid to ask stupid questions, and don't give up if they look at you strangely.

≈ If a manufacturer is unwilling to sell you a small quantity (maybe they only sell the textile by the semi-truck load, for example), see if a mainstream user of the material will sell you some or order some for you.

≈ Textiles are very versatile. You can silkscreen many of them, you can stencil them and even color photocopy on them. You can also mount textiles on paper or another solid material.

≈ Explore unique binding options. Sew them, tie them, pin or glue them—the sky is the limit!

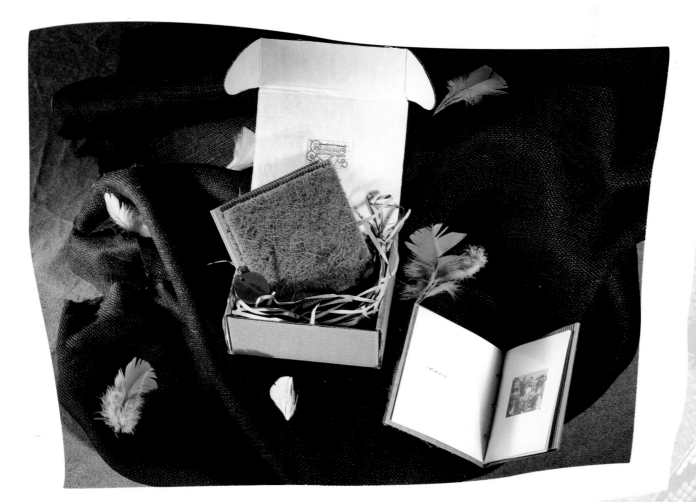

4 The last step was adhering the
coconut husk squares to the cover
of the booklets. The designer used
construction adhesive—a material that's
sold in a tube like caulking—that was
left over from his building renovation.

Other design uses for textiles:

- ◉ Brochure covers
- ◉ Packaging
- ◉ Invitations
- ◉ Announcements
- ◉ Limited-edition CD covers
- ◉ Portfolios
- ◉ Photography background for print ads
- ◉ Custom items such as lamp-shades, coasters and clothing

5 To mail the booklets, the designer used white stock boxes turned inside out to the brown side. The boxes are embellished with the design studio's custom label "stamps." Shredded paper scraps protect the booklet inside the box.

Gallery

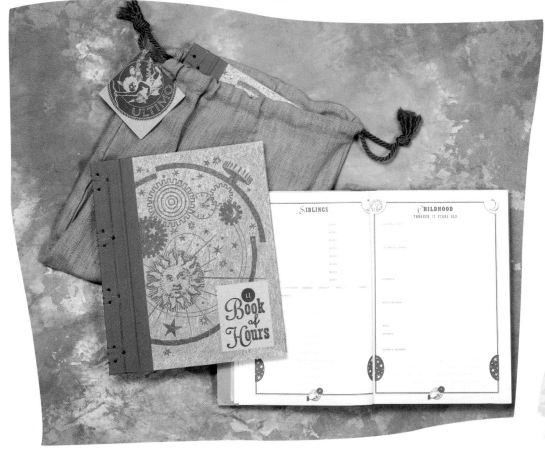

Chipboard covered with handmade banana paper forms the cover of this book: a gift to clients of a design firm. The primary printing process was letterpress, including the small square of sandpaper on the cover. Custom-made fabric bags, complete with coordinating tassel draw-strings, add another level of texture to the piece. The unit cost of the books was $40; 125 were produced. Design Firm: Ultimo, Inc.

The designer of this brochure for an arts organization reports that his biggest challenge was "finding the material at all. No one seemed to want to understand what I was attempting. I guess the quantity was too small." The material in question—known as shotte pad material—is shredded textile waste materials blended with lint and glue to hold it together, a material usually used as a filler in mattresses and bedding. The soft, loose nature of the product made binding the brochure a challenge. Design Firm: Palazzolo Design Studio

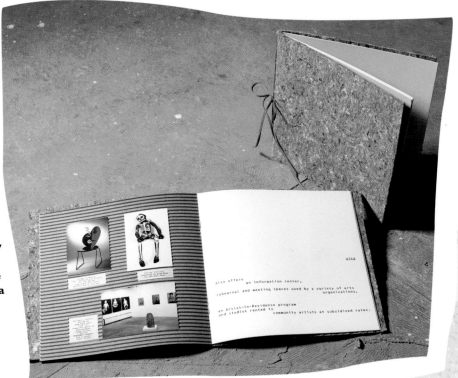

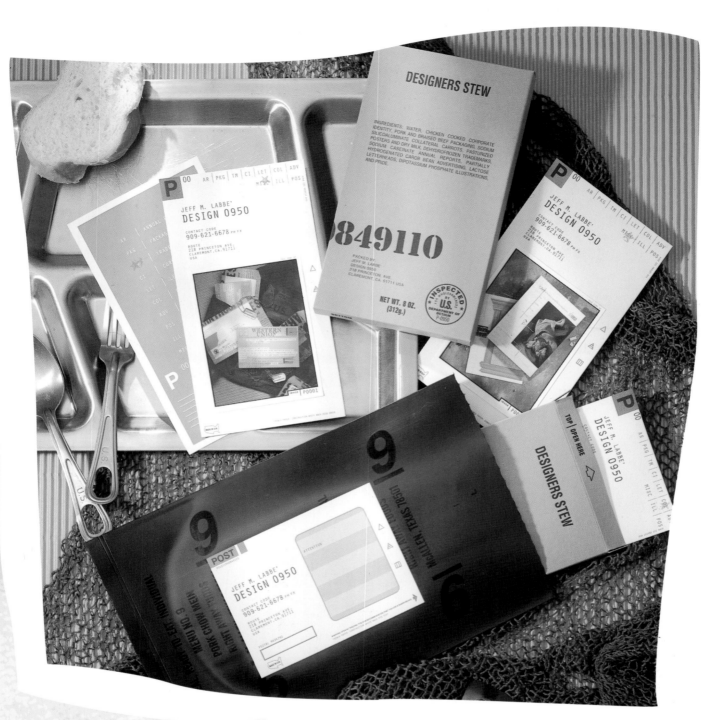

DESIGNERS STEW

INGREDIENTS: WATER, CHICKEN COOKED CORPORATE IDENTITY, PORK AND BRAISED BEEF PACKAGING, SODIUM SILICOALUMINATE COLLATERAL CARROTS, POSTERS AND DRY MILK, DEHYDROFROZEN PASTURIZED SODIUM CASEINATE ANNUAL REPORTS, PARTIALLY HYDROGENATED CAROB BEAN ADVERTISING, LACTOSE LETTERHEADS, DIPOTASSIUM PHOSPHATE ILLUSTRATIONS, AND PRIDE.

849110

PACKED BY:
JEFF M. LABBE
DESIGN 0950
218 PRINCETON AVE
CLAREMONT, CA. 01711 USA

NET WT. 8 OZ.
(312g.)

In keeping with his corporate identity's World War II theme, this graphic designer found a packaging vendor who manufactures ration kits for the U.S. Army. The bags are made of a poly-plon propylene material and are sealed with one open end. To seal them for mailing, the designer applies direct heat—from a curling iron, for example—or has them sealed at a local packager if the quantity warrants it. Inside this bag is a box with cards featuring pieces from the designer's portfolio.
Design Firm: Jeff Labbé Design

"Trail Guide" trial-sized toiletries arrive in a small burlap sack, that suggests the practicality of camping equipment. The scaled-down quantities are practical enough to be slipped into a backpack for camping, skiing, or just heading off to the gym. The bags were washed after printing for added effect, making this packaging that communicates a lifestyle. **Design Firm: Cato Gobé & Associates**

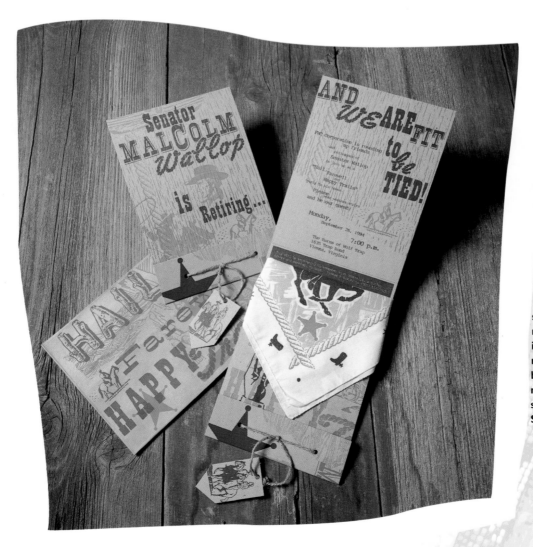

Custom bandannas were screen-printed to complement this western-motif invitation. Tied around the matchbook-style chipboard mailer, the bandanna is held in place with a simple knot. **Design Firm: Sayles Graphic Design**

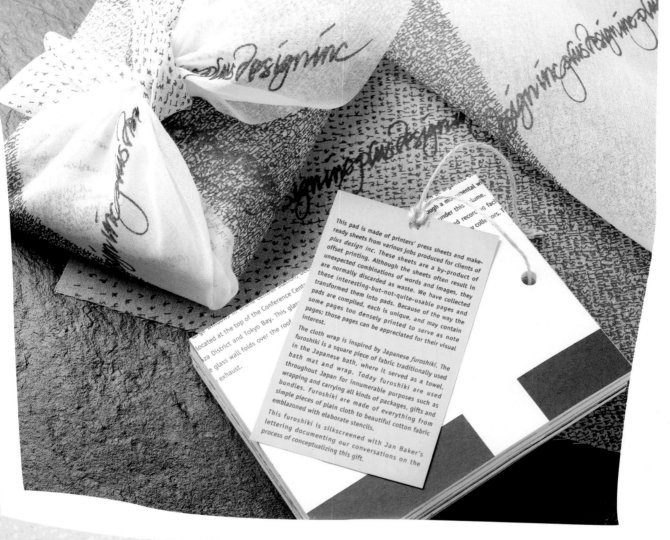

This pad is made of printers' press sheets and make-ready sheets from various jobs produced for clients of *plus design inc.* These sheets are a by-product of offset printing. Although the sheets often result in unexpected combinations of words and images, they are normally discarded as waste. We have collected these interesting-but-not-quite-usable pages and transformed them into pads. Because of the way the pads are compiled, each is unique, and may contain some pages too densely printed to serve as note pages; those pages can be appreciated for their visual interest.

The cloth wrap is inspired by Japanese *furoshiki*. The furoshiki is a square piece of fabric traditionally used in the Japanese bath, where it served as a towel, bath mat and wrap. Today furoshiki are used throughout Japan for innumerable purposes such as wrapping and carrying all kinds of packages, gifts and bundles. Furoshiki are made of everything from simple pieces of plain cloth to beautiful cotton fabric emblazoned with elaborate stencils.

This furoshiki is silkscreened with Jan Baker's lettering documenting our conversations on the process of conceptualizing this gift.

This gift notepad is made of make-ready and press sheets from various print projects. Normally discarded as waste, the sheets often feature multi-level images. The idea for the cloth wrap encasing the pad is taken from a Japanese multi-purpose fabric called furoshiki. These fabrics are used and re-used for wrapping and carrying. Design Firm: plus design inc.

Designing with Wood

Zubi Design

What do you get when you team an architect with a graphic designer? You get Brooklyn, New York, based Zubi Design, which consists of the husband-and-wife team of architect Omid and designer Kristen Balouch. When the pair realized their different kinds of design complemented each other, they decided to start their own studio together.

CREDITS:

Design Firm: Zubi Design/ Brooklyn, NY

Client: Boxart, Inc./ Brooklyn, NY

Graphic Design: Kristen Balouch

Structural Design: Omid Balouch

Wood Blocks: Brown Wood Products Co./Northfield, IL

Bass Wood: Trend·lines/Revere, MA

Silkscreening: Zubi Design/ Brooklyn, NY

Silkscreening Supplies: Pearl Paint Art Supply Store/New York, NY

Quantity Produced: 70

As a result of this blend of unique talents, Zubi Design's work usually walks the fine line between graphic design and craft. Omid's architectural perspective gears the firm towards three-dimensional projects such as furniture, boxes and toys, with wood being a favorite medium for executing these projects. Kristen creates the surface designs for projects and other print-related pieces such as books and direct mail promotions.

The design team created "A Box Full Of Art" as a Christmas promotion for Boxart, Inc., a fine art crating and packing company. The promotional gift is a wooden crate with a sliding lid containing six wood blocks that spell out the company's name in playful typefaces. "A Box Full Of Art" visually portrays Boxart's mission—fine art inside a crate. Initially the team considered portraying each of Boxart's services, in icon form, on the blocks. This theme would have aggressively promoted the "building blocks" of the company: crating, packing, storage and shipping services. However, Kristen and Omid decided a simpler approach—spelling out the company's name— would be more appreciated by Boxart's clients. Since each block featured a letter designed in six different type styles, recipients could arrange the blocks in their own unique way, making each gift more personal.

The project showcases each member of the design team's expertise. Kristen designed the typefaces herself—six for each block—on the computer. Omid custom-designed the crate. Omid and Kristen silkscreened the blocks and lid of the crate themselves. "It was the first time we silkscreened a project," Kristen explains. "We silkscreened one block at a time. This project was designed in 72 colors; each color requires a screen. On subsequent projects I've designed my color schemes differently so fewer screens are needed. Printing two colors each evening, it took us a month to silkscreen 70 crates and 420 blocks."

Kristen explains that since wood is organic by nature, it varies in texture, tones and density. This makes each piece of wood unique. "We enjoy working with wood because the projects we design are very durable and age well. We want the people who receive our objects to enjoy and cherish them," she says. "A Box Full Of Art" was both mailed and hand delivered to Boxart's clients. The crating company was flooded with faxes from appreciative recipients. "People loved them," Kristen reports.

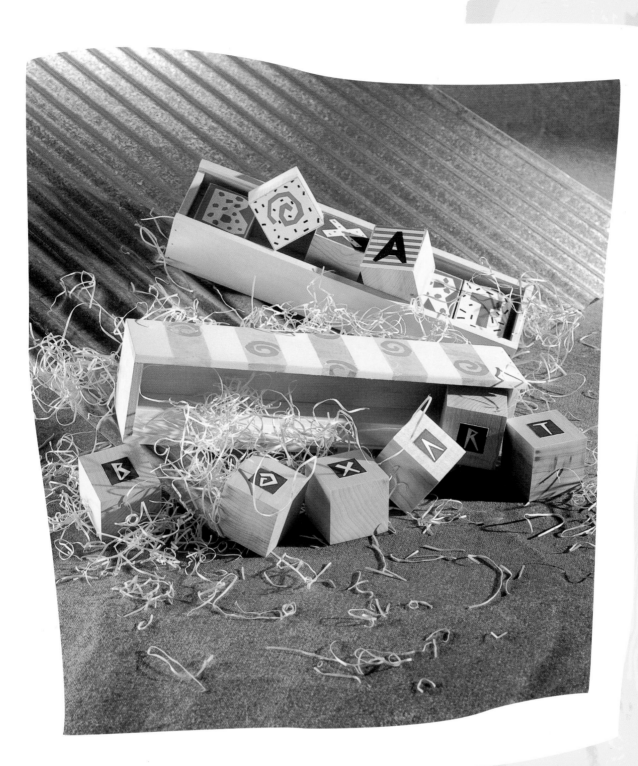

1 Kristen and Omid started planning Boxart's Christmas promotion in August. They sketched out their concept for a crate containing six 2" blocks of wood. Kristen then went to work on her computer, designing six typefaces for the letters on each block using Aldus Freehand. Meanwhile, Omid planned his design for the crate and experimented with some wood on hand. The client approved Kristen's sketches for the blocks right off the computer screen. Kristen printed samples of her type designs on a color laser printer and glued them on six blocks of wood she had on hand and experimented staining designs on Omid's early crate prototypes—the result of this early experimentation is shown here.

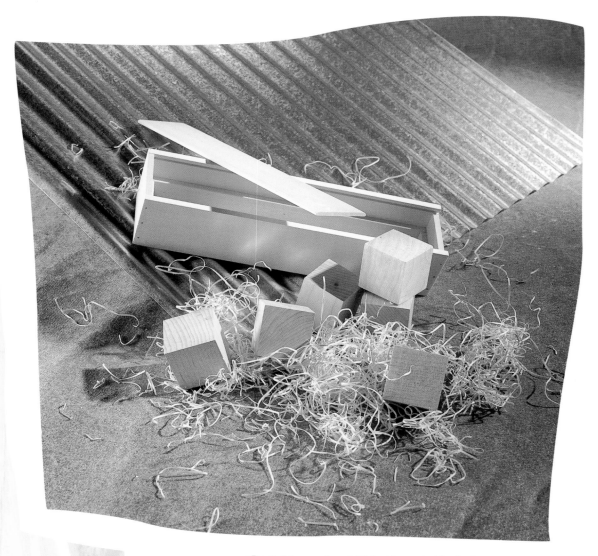

2 Kristen ordered 2" hard maple blocks from a custom woodworking company. She chose maple because it is durable and won't splinter, dent or crack. Since the blocks were in maple, Omid wanted a light wood for the crate to make the piece lighter and easier to mail. He chose basswood because it was easy to cut and sand, and it was available in a convenient and lightweight $1/4$" thickness. He ordered a sample of basswood from a catalog and made a prototype.

Woods 101

Even if you're working with a woodworker, you'll need to know the properties of different woods such as color, texture, strength, hardness, workability, finishing qualities, availability and cost. Common varieties include:

- Ash. A hard wood with a very attractive grain. Is expensive.
- Bass. A lightweight wood that's easy to cut and sand. It is quite fragile and dents easily.
- Birch. Hard wood similar to maple, but readily available in plywood.
- Cherry. Has a deep red color that ages well. Is expensive.
- Maple. Recommended for children's toys because it won't splinter. Available in hard and soft maple. Shrinks more than birch. Available in different grain figures.
- Poplar. Is inexpensive and ages nicely, but splinters. It is usually used as a utility wood.
- White Oak. A hard wood with a warm color and feel.

For more detailed information about the properties of various woods, see *The Woodworker's Guide to Selecting and Milling Wood* by Charles Self (Betterway Books).

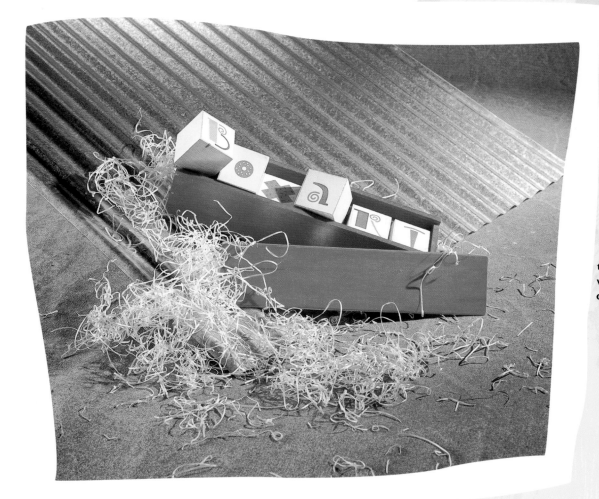

3 Kristen stained Omid's final prototype crate red by rubbing a gel stain on the wood with a cloth. After viewing the red prototype shown here, the client made the decision to go with a natural wood crate that wouldn't compete with the bright colors of the blocks inside.

Tips for great design with wood:

≋ Working with wood is time-consuming. You can create the design for a project, but if you don't have much experience with wood, consider hiring a woodworker for production. You can locate a good one in the phone book or from woodworking magazines.

≋ Use woods from a responsible source, rather than exotic woods from the rain forest.

≋ Wood is available in many different forms including solid lumber, plywood (thin layers of wood glued together) and veneer (a thin layer of fine wood laid over the surface of another wood). Solid lumber and plywood have dimension and structural strength, and they're ideal for large projects; veneers are used for decorative purposes.

≋ Wood has its limitations, but its behavior can be predicted and worked with. Each piece of wood has unique qualities, since even boards cut from the same tree have their own unique color, grain and density.

≋ You can purchase wood from a lumber yard or by mail order. The price of wood varies greatly depending on your location, where you buy it from and how finished the wood is. For example, if you need a thin sheet of wood, it may have to be planed down from a wider width. If you order a large quantity, this can be done by the lumber yard, but will add to the cost.

≋ When working with wood, always wear goggles and use a dust mask when sanding or cutting.

≋ Many wood finishes are available, from colored gel stains and dyes to wax and oil sealers that protect wood's natural color. If you're applying the finish, make sure to do lots of tests first. If you are having a woodworker do it, they'll be able to advise which finishes will get you the effect you want.

≋ Silkscreening is the most popular method of printing images on wood. Designing the surface for a wood project is similar to designing a printed piece. Some designs can be harder to print than others, so when designing for silkscreening on wood, avoid designs with traps and bleeds. Always keep in mind the printing order of colors and the opacity or transparency of the inks.

Other design uses for wood:

- @ Book covers
- @ Packaging
- @ Three-dimensional objects
- @ Brochure covers
- @ Invitations
- @ Announcements
- @ Awards
- @ Menu covers
- @ Point of purchase displays

4 Kristen and Omid silkscreened the blocks and crates themselves. Kristen printed out the block artwork from the computer and the pair cut films for each color out of Stay-Sharp, a film used in silkscreening, using the printouts as guides. Then they stretched 12xx Dacron screen on a 10" frame of stretcher strips. The Stay-Sharp films were adhered to the screens with a Stay-Sharp solvent. Omid built a wooden print bed to hold the blocks.

A screen was registered and clamped into place, and then a block was placed in the print bed and printed with environmentally friendly water-based ink, with a squeegee being used to apply the ink to the screen; one color was applied at a time. Each block had six sides, with two colors on each side, for a total of 12 screens per block. There were six blocks in all, so 72 different screens were created. The couple silkscreened two screens each evening over a month.

In the meantime, all the components of the crates were cut from basswood on the table saw. Omid routed a groove in each side piece, so the lid would have a "track" to slide in. Then, using wood glue and brad nails, he attached one end of a box to one side. A ¹/₂" wood "ledge" was then glued in the inside center of the side pieces. The ledge held the blocks securely in the crate, but gave "finger room" so the blocks could be removed easily. Using a jig to keep the box's angles square, Omid nailed and glued the two halves of the boxes together, then sanded them with a palm sander and fine, 120-grit sandpaper.

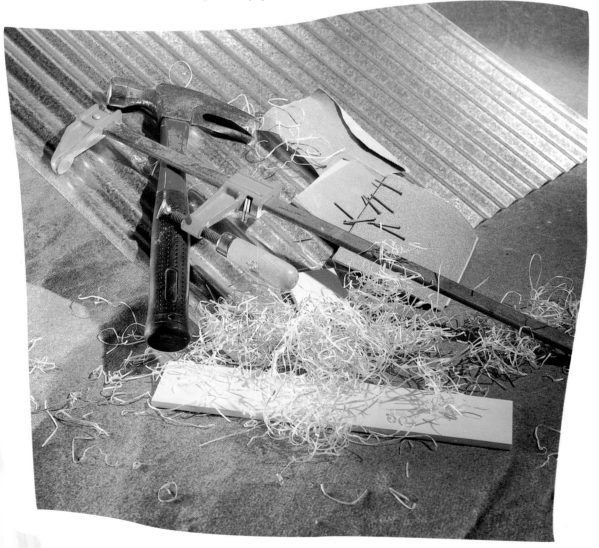

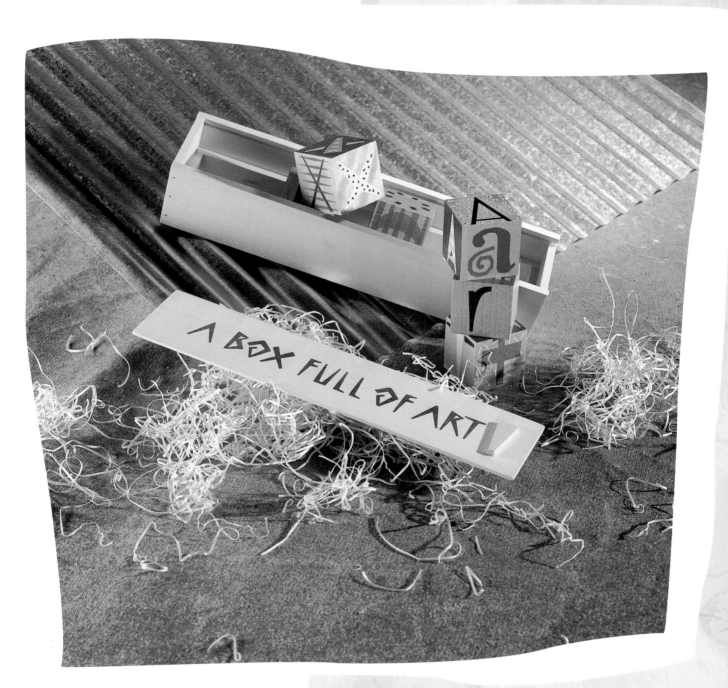

5 Omid cut the box lids and bottoms. He hand sanded the edges of the lids round so they'd slide inside the grooves smoothly. The lids and bottoms were then silkscreened in the same manner as the blocks. A pattern of stripes and the words "A Box Full Of Art" were printed on the lids and a copyright mark was printed on the boxes' bottom pieces. The bottoms of the boxes were glued in place.

Omid cut the handles—small, triangular pieces of basswood—with an X-acto knife and hand-sanded them. Kristen finished them with a yellow gel stain rubbed on with a cloth, and Omid glued the handles to the lids.

A white, translucent gel stain was rubbed onto the finished boxes to protect the surfaces and add a pickled effect. The boxes were allowed to dry for 24 hours. The wood blocks were sprayed with polyurethane to protect the finish, allowed to dry, then placed inside the boxes.

Gallery

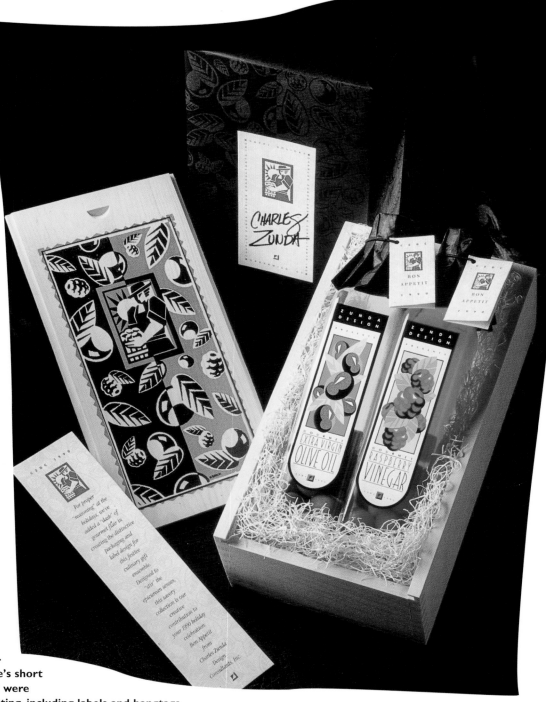

A custom pine display box is adorned with two colors of screen-printed ink to showcase a design firm's packaging capabilities. Because of this piece's short production run (only 150 were produced), nearly all printing, including labels and hangtags, was done via screen printing. The black wrapping paper is black Kraft paper which has been photocopied: toner provides the varnished effect. Design Firm: Charles Zunda Design Consultants

The lumber used for this holiday gift—a promotion from a firm that packages fine art in wooden crates—is ¹/₁₆" birch, selected for its natural flexibility and suitability to the particular design. The screen-printed boxes are finished off with a custom handle attached with a screw. Eighty pieces were produced at a total project cost of $12,000. Design Firm: Zubi Design

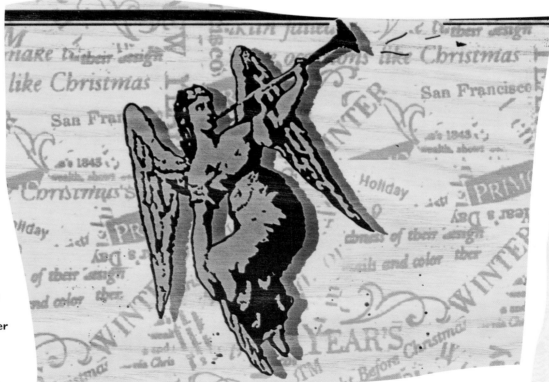

This postcard mailer is made from veneer—wood backed with paper which is available in specialty hardware stores. The image was printed onto the wood surface by laser printer—fed into the printer against the grain, since with the grain the wood is too stiff. The postcard was trimmed after printing to achieve the effect of words bleeding off the edges. Design Firm: Primo Angeli Inc.

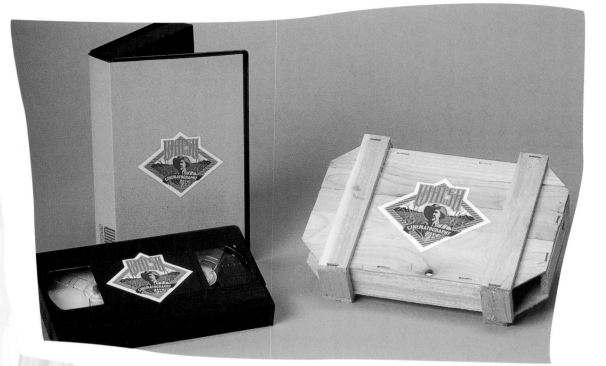

A local craftsman builds these video crates on an as-needed basis for about $5 per unit as a rustic promotion for a cinematographer. Heavy-duty copper staples keep the crates together while enhancing the rugged look and feel of the piece. Four-color adhesive labels, designed to reference old movie posters, provide a finishing touch and a bit of color. Design Firm: Design Services, Inc.

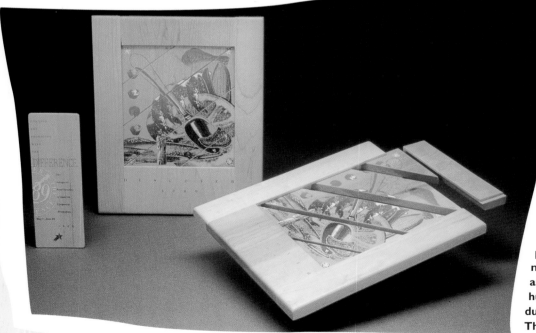

Initially, maplewood frames measuring 12" x 16" x 1¹/₄" were sent to recipients, along with one piece of the screen-printed plaque inset. Each week, one more piece was sent to build anticipation. A total of one hundred plaques was produced at a unit cost of $40. The design firm contracted with a woodworking company to fabricate the project. Design Firm: Hornall Anderson Design Works

Designing with Metal

When Maria Dominguez and Robert Little of Blue Sky Design were asked to design a menu for a one-of-a-kind restaurant, they knew ordinary materials wouldn't do. The restaurant was called Rocca, Italian for "rock," and offered patrons the unique experience of cooking their own meal at their table on a flat rock heated to 500 degrees. The interior design of the restaurant featured an unusual blend of natural and man-made materials, such as stone, leather and iron, and the designers wanted Rocca's menus to capture the rustic, tactile essence of the restaurant's dining experience.

CREDITS

Design Firm: Blue Sky Design/Miami, FL

Client: Rocca/Coconut Grove, FL

Art Director: Maria Dominguez

Designers: Maria Dominguez, Robert Little

Sheet Copper: J.M. Tull Metals Company/ Miami, FL

Metal Fabrication: Engineering Metal Fabrication/ Miami, FL

Leather Fabrication: Robert Little

Copper Tubes: Rex Art Company/ Miami, FL

Offset Printing/ Lamination: Offset Express/Miami, FL

Quantity Produced: 100

The resulting menu was born from Dominguez's design for Rocca's letterhead, which featured a marble texture and copper foil stamp. The base of the menu is a rectangular copper sheet with rounded corners. Menu pages are protected by a laminated paper cover printed with a marble pattern and Rocca's logo. The pages and cover are secured to the copper back so they are easy to remove and update: Black rubber bands are threaded through punched holes and wrap around a narrow copper tube cushioned by a strip of leather. The menu has a primitive yet streamlined look and presents a mix of textures pleasing to the sight and touch.

Little says the biggest challenge in creating the menu wasn't convincing the clients to use non-traditional materials—it was sourcing them. "The secret was to think about the everyday ways these materials are used," he says. For example, there was no listing in Little's phone book for "Little, Round Black Rubber Bands." After almost giving up on the quest for the bands, Dominguez happened to visit her father at his VCR repair shop. She noticed him replacing a VCR's drive belt, which is a little, round black rubber band. "They worked perfectly," says Dominguez. The leather strips also came from an unexpected source. "Rocca's interior designer was taking us on a tour when the upholstery on the chairs was being done. The floor was full of leather scraps. We had planned to get our leather at a fabric store, but the scraps were going to be discarded anyway, and they were a great 'tie' to the restaurant's decor," Little says. The menu's copper tubes were discovered in Little's local art store. "They're used by architects to build models," he says.

The designers discovered that the challenge in sourcing sheets of copper is that most metal manufacturers they contacted didn't want to deal with a small quantity. "They're used to selling it by the ton," Little points out. "We just called every metal manufacturer in the phone book until we found one willing to work with us."

The designers' perseverance and creative thinking paid off. "I really encourage other designers to try using non-traditional materials in their work. This project was fun, challenging and a joy to do," Little says. "It gave a sense of accomplishment a plain paper project can't match."

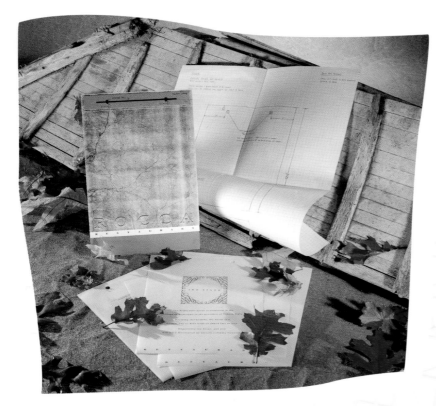

1 Inspired by Rocca's unique environment, Dominguez started drafting ideas for the menu, keeping in mind the concept of including materials used in the restaurant's interior design. Her only parameter was that the menu pages be easy to update. She took her final layout to the client, who approved the menu design immediately with no changes—a rare thing in the design business. The menu's size was determined by the fact that the interior pages would be laser printed on 8½" x 11" paper (to allow the menu to be revised on demand). Dominguez and Little worked out the dimensions for each of the menu's elements by making a prototype out of paper and cardboard (shown here).

2 The designers sourced the copper for the menu backs first, calling various metal suppliers listed in the Yellow Pages. Many suppliers weren't interested, since such a small quantity of metal was required. They finally found the J.M. Tull Metal Company. Tull's staff helped the designers choose the proper thickness of copper to allow the menus to be both lightweight and durable. Little bought four 4' x 8' sheets at $105 per sheet, with each sheet yielding 25 to 28 menu backs.

Little started looking for a metal fabricator to cut the copper and punch holes for the binding. He discovered Engineering Metal Fabrication, designers and manufacturers of industrial and commercial metal products; they agreed to take on the designer's project. Little faxed a scale layout of the menu to the metal fabricators and got a quote of $2.50 per menu to cut the copper, punch the holes and grind the metal edges smooth. The designer had Tull Metal Company deliver the copper directly to the metal fabricator, and in one week Little had his menu backs in hand. He decided to keep the copper's natural finish, but spray the menu backs with a clear lacquer to cut down on fingerprints and the "metal odor."

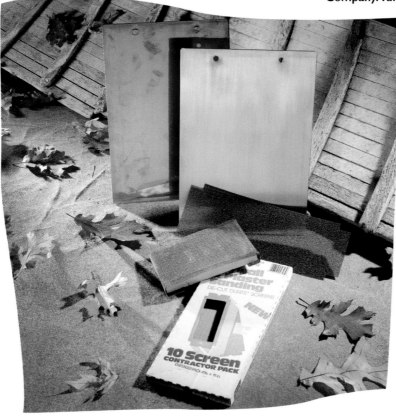

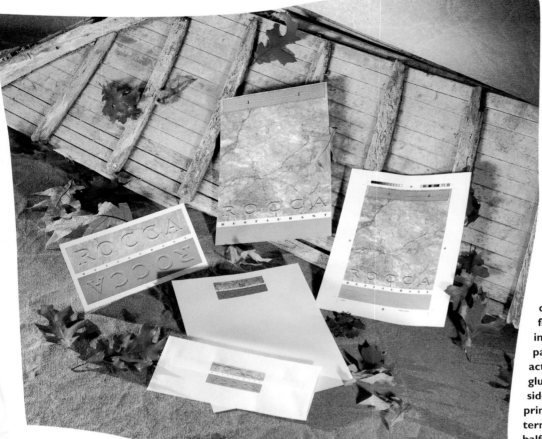

3 The mechanicals for the cover art came next. For durability, Dominguez specified custom 130# cover stock in Neenah Classic Linen duplex paper, a type of paper that's actually two pieces of paper glued together, white on one side and gray on the other. The printer created the marble pattern on the covers by shooting a halftone of an actual piece of Italian marble. The covers are printed in two colors, green and black; the white color is the paper showing through. The covers were offset printed and laminated to protect them from spills. The printer also punched holes in the covers and scored them so they'd open easily.

Tips for great design with metal:

🌿 Before you design with metal, find out more about it. Take a tour of a metal fabrication company or visit an artist's metalworking studio. Ask questions, and you'll come away with valuable information and creative ideas.

🌿 Don't be afraid of using metal in a project just because you've never seen it done before. Get some metal samples from a manufacturer and experiment with them.

🌿 Metal is available in more than just flat sheets. Try using square or round metal tubes or rods and prefabricated items such as ball bearings, nuts and bolts, hinges, coils and decorative pieces.

🌿 Source your metal early. Make sure you can obtain it before your client's deadline.

🌿 Think through whether metal will work for your project practically, and choose the metal for your project accordingly. If you're designing a metal menu, can a waitress carry a stack of them easily? Can the fabricator deliver 1,000 metal boxes to your third-story design studio? If the piece will be mailed, you may want to choose a light metal like aluminum. If the piece will be handled a lot, you'll need to choose a durable metal like steel, or if you do choose softer metal such as copper, you'll need to use it in a thickness that can't be bent easily.

🌿 Metal can be stamped, engraved, embossed, die-cut, folded, printed and extruded. Talk to local trophy companies, machine shops and specialty metal fabricators to get ideas and source these services.

🌿 A variety of finishes—brushed, sand-blasted, distressed, polished, antiqued or natural—can be achieved with metal.

🌿 If your metal piece is to be handled a lot, make sure the edges are filed dull to make the piece safe to handle, and that the project is coated with lacquer to cut down on fingerprints and eliminate the odor metal can leave on hands.

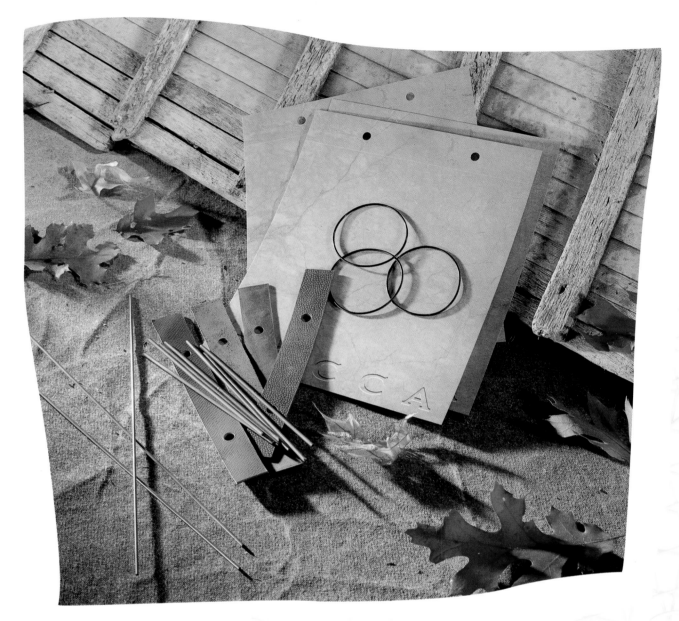

4 Dominguez and Little used scraps of leather left over from the restaurant's upholstering for the menus. The leather was cut into strips with an **X-Acto** knife. Little thought punching holes into the leather for the binding would be easy, but he ended up borrowing the bit from his printer's mechanical punch and punching out the holes by hand—very hard work that he recommends other designers source out, if possible. They found the copper tubes—usually used by architects to build models—in a local art supply store. Dominguez selected the appropriate diameter tubes in 12" lengths, and Little cut them in half with wire cutters and then sanded the cut edges smooth. Each tube cost 33 cents. The black bands that hold the menu together are **VCR** drive belts; wholesale, the belts cost 50 cents each.

5 Dominguez had the menu pages laser printed, then the entire staff at Blue Sky spent three days lacquering and assembling the menus and demonstrating to the client how they went together. The entire Rocca menu project took three months to complete, with the metal sourcing alone taking three weeks. Little says he's glad he made plenty of extra samples of the menus—their non-traditional approach has made quite an impression on Rocca's customers and in the design world.

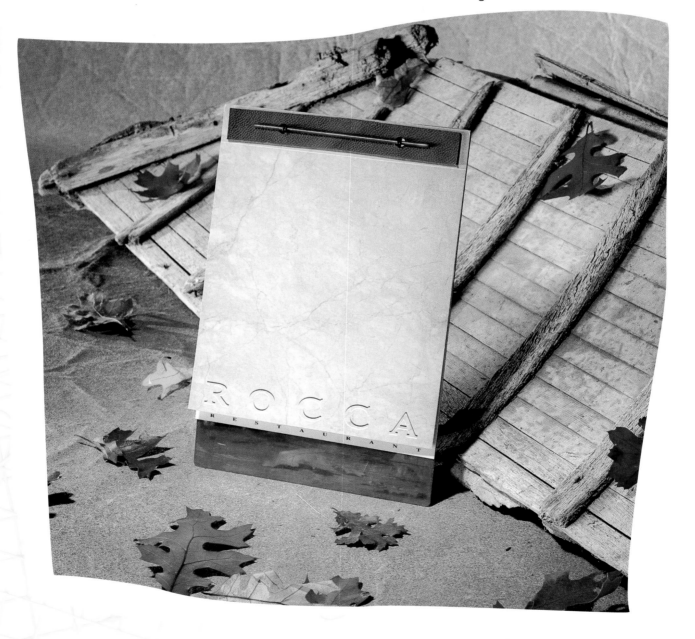

Gallery

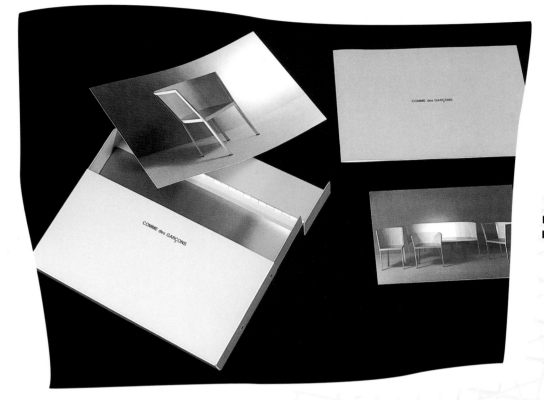

The owner and designer of furniture company **Comme des Garçons** wanted a catalog that could be updated at any time, so the design was developed based on loose-leaf, 100# cover stock. Custom-made aluminum boxes, screenprinted with the company name, were produced to house the initial run of 5,000 catalogs. **Design Firm: Matsumoto Incorporated**

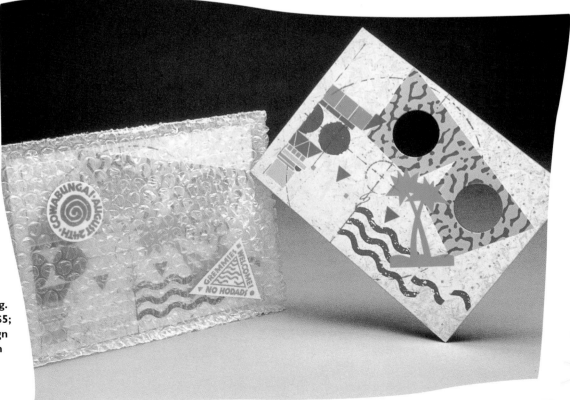

Galvanized metal forms the basis for this open-house invitation. A sign company cut the metal, including the die-stamped holes, which was then screen-printed in four match colors. The edges of the invitation were ground smooth and the piece was inserted into bubble-wrap sleeves for mailing. The cost per unit was $5; quantity was 750. **Design Firm: Hornall Anderson Design Works**

Promotional T-shirts are packaged in Kraft paper canisters with metal lids, re-enforcing the "durable goods" theme. The use of different sizes of cans adds variety and visual interest. Design Firm: Cato Gobé & Associates

Galvanized metal had to be "prepped" before printing by cleaning it with soap and water for this project. Other special steps included the filing of sharp edges and corners. The firm was able to eliminate any waste or spoilage of materials due to the fact that misprints could be wiped off the metal while the ink was still wet. The invitation was mailed in an envelope with vellum to protect it. Total project cost was $3,000 for 550 units. Design Firm: NBBJ Graphic Design

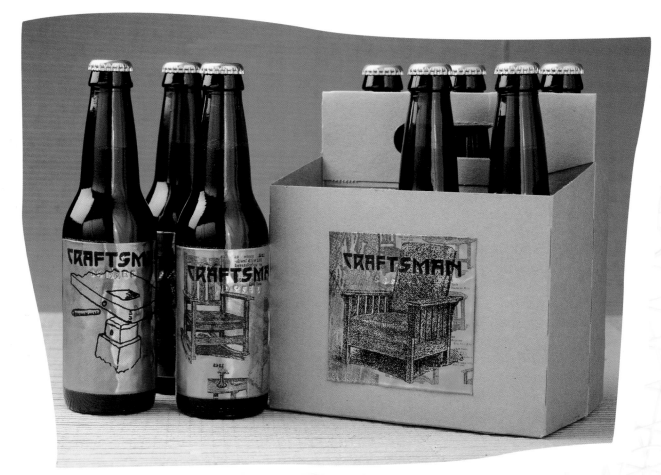

The packaging for this limited-edition beverage—"Craftsman Coffee"—was enhanced with a copper label. Purchased in roll form at a metal supply shop, the thin copper was screen-printed with no preparation of the metal being necessary. The designers trimmed the labels by hand and applied them to the bottles and chipboard carton with a spray mount adhesive. Design Firm: Newton/Stover Design & Illustration

Produced entirely with donated time and materials, this design award is a hanging mobile constructed from aluminum, brass, copper and string. The designer says assembly of the piece was difficult, calling it "a tough fit and very tricky handwork." Type on the awards was screen-printed before assembly. Design Firm: Clifford Selbert Design

A business card for a graphic designer, this 3" x 2¹/₂" World War II signaling mirror was purchased at a United States Government Surplus Store. The mirrors came with already-rounded corners, a die-cut center hole and a polished mirrored side, which was covered with a protective adhesive backing. Each mirror was washed and subsequently black-etched on the exposed metal side. The adhesive side was hand-stamped using a rubber stamp. Design Firm: Jeff Labbé Design

The cover of this brochure for a boat trailer manufacturer is a study of contrasts: metal purchased from a scrap yard and feathers gathered at a local park. The $1/32$" thick sheets of aluminum are adhered to cover weight paper with a construction adhesive; the feather is held in place with Elmer's glue. The materials were selected to represent the strong—yet light-weight—trailers produced by the client. Design Firm: Palazzolo Design Studio

A self-promotional brochure for Tennessee-based design firm Steelhaus, this piece features a hand-cut aluminum cover attached to printed pages with a screw post. The metal was cut using a standard sheet metal shear, then punched to create a hole for the screw. Metal washers take up space and help ensure a snug fit. Finally, an adhesive label is applied to the front cover. Design Firm: Steelhaus

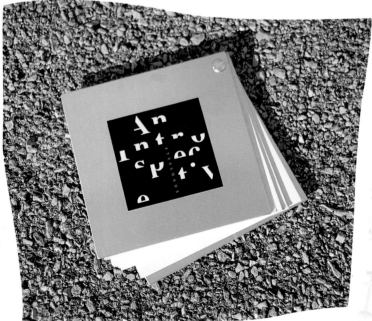

In conveying the urgent need for peace and forgiveness, this holiday greeting mimics a telegram, like those sent to the families of soldiers who were killed during World War II. The telegram was produced with what the designer calls a deliberate "anti-computer look," and featured copy printed onto "lick and stick" labels, which were then adhered to cover weight paper. The dog tags were produced with a metal stamp machine purchased through an Army surplus dealer. A total of two hundred holiday greetings were produced at a unit cost of less than $4. Design Firm: Jeff Labbé Design

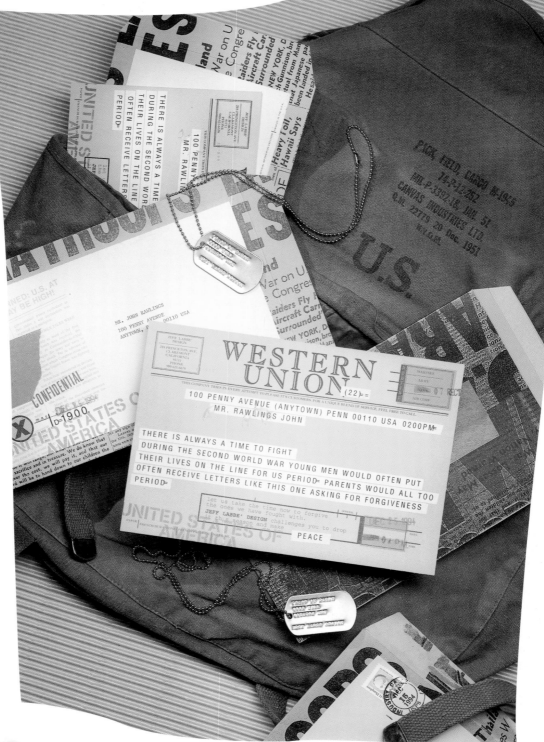

Designing with Unique Bindings

Diversified Graphics

As more designers try non-traditional materials, they discover that traditional types of bindings—such as perfect binding and saddle stitching—don't always work artistically or practically with these types of projects. Designers looking for ideas on how to bind their non-traditional pieces often rely on trial and error to find the right solution. Some printers may be able to help, but many aren't familiar with unusual media such as wood, textiles and handmade paper. If you're going to work extensively with non-traditional materials, it may be worthwhile to seek out a printer with special expertise in binding them.

Diversified Graphics in Minneapolis, for example, is recognized as a pioneer in the field of non-traditional bindings. Since the mid-1980s, Diversified has helped designers choose and produce unique bindings. Lisa Henkemeyer, Diversified's specialty printing manager, acts as a creative consultant to clients and designers in their specialty projects, providing insight on time frame, costs, production, resources and materials. Henkemeyer says unique bindings tend to be a fairly practical choice, since, when well-planned, they often take little more time or money than more traditional methods.

But even more importantly, in a culture where glossy, four-color, staple-stitched booklets are the norm, "a project with a unique binding is going to stand out," Henkemeyer says. "[Unique bindings] add a tactile quality that traditional bindings cannot duplicate. A unique binding becomes part of the design of a piece and sets a mood. People tend to keep a booklet with a unique binding because it feels more special and personal, like a keepsake," she adds.

Diversified is always coming up with new and creative bindings such as using unique hardware combinations and sewing techniques. "Any project can become extra special with a non-traditional binding," she says.

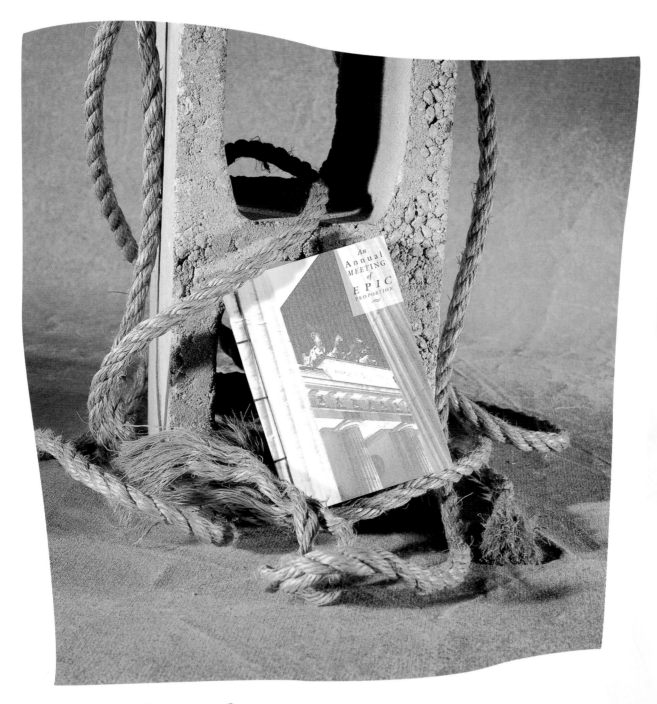

Japanese-Sewn

Japanese-sewn bindings consist of thread or other material hand-sewn through a pattern of holes. Since they take more production time than machine-sewn bindings, they are the most expensive type of bindings, and thus are generally used for smaller print runs. A typical hand-work service can produce 500 to 1,000 pieces per day and usually bills by the hour. If your printer does not have a hand-work source, fulfillment houses, youth groups and senior citizen centers are alternatives for hand-work labor. There is no standard thickness of booklet suggested for this type of binding; it is very flexible. The booklet must be trimmed to final size before it is sewn. First, holes are drilled with a conventional drill or punch. Thread, yarn, string, ribbon, raffia, twine, rope, wire or other material is then looped and tied through the holes in a continuous pattern. This type of binding is looser than machine-sewn, so if a heavy paper is used for the cover or pages of a booklet, the pages must be scored to lay flat. The binding material can be tied in a variety of creative ways by looping the material in different patterns. To add a different look, the holes can be drilled in a uniform or random pattern, in one row or several. Beads, conchas, tags, medallions and other elements can be threaded through the loops to add dimension. **Design Firm: Wiggin Design, Inc.**

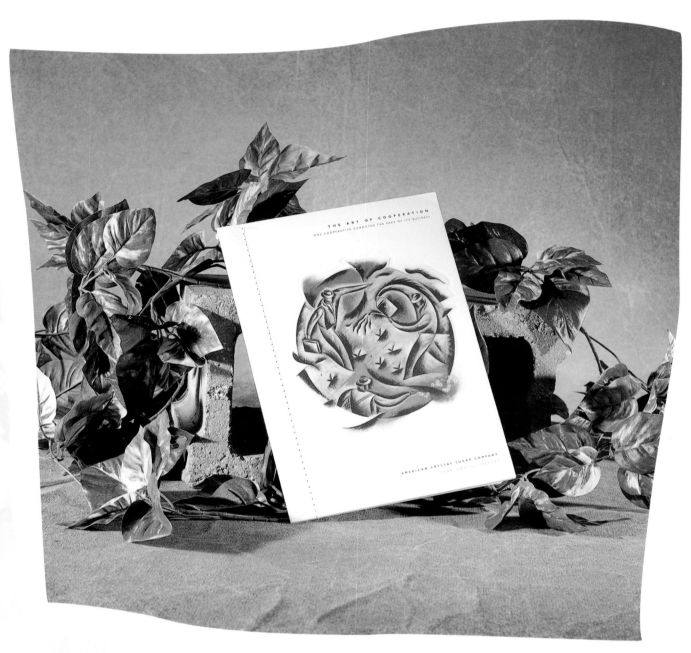

Machine-Sewn

Machine-sewn bindings are actually guided by hand on a heavy-duty sewing machine. The binding can be sewn down the spine or can be side-stitched down the left side, as shown here. Sewing down the spine is less secure and is usually done on thin brochures. This type of binding is less expensive than Japanese-sewn and is practical up to a maximum thickness of $^3/_8$". A strong thread is needed because machine stitching is tight; metallic thread, for instance, is usually too fragile. On the other hand, extra heavy thread, such as carpet thread, requires an industrial sewing machine. To ensure the right thread color, texture and strength, always have a proto- type made incorporating the actual materials you'll be using. Different colors of thread can be used for the top and the bottom of a booklet. Pages are trimmed to final size before collating; the booklet cannot be trimmed on the top or bottom after it is sewn because the stitches would be cut. Upholsterers, costume-makers, tailors and other commercial sewing companies are good sources to try for machine-sewn bindings. **Design Firm: Miller Measter Advertising.**

Pamphlet-Sewn

This simple, hand-sewn method threads through three holes in the gutter of 4, 6 or 8 pagers, so the stitches are hidden. Maximum flat thickness is 1/8". Single, double or triple color threads, or thin cords can be used. The stitch can be done on the front or back of the booklet, off the spine edge. The knot that secures the thread is usually hidden in the inside center, but can be moved to the outside of the book to add an attractive design element. **Design Firm: BI Performance Services.**

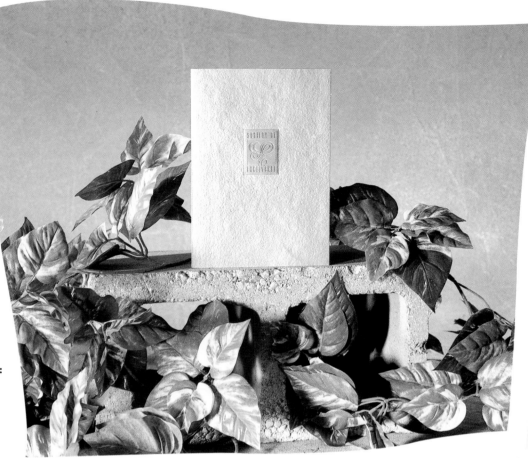

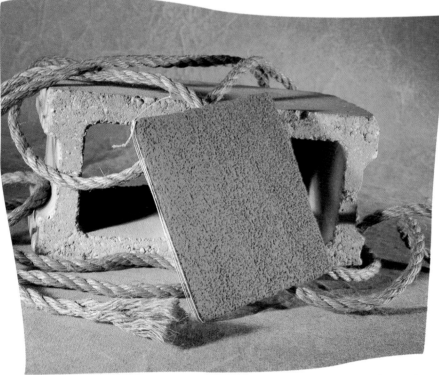

Design uses for non-traditional bindings:

- Brochures
- Annual reports
- Invitations
- Announcements
- Sales incentive promotions
- Catalogs
- Folders
- Direct mail promotions
- Books and journals
- Greeting cards

Hand-Tied

Hand-tied bindings are not actually sewn— thread, cord, yarn, ribbon or other material is simply looped around the cover of a booklet and the pages slipped through. This type of binding is flexible and is commonly used for restaurant menus. It is not practical for booklets with a large number of pages. **Design Firm: PaceWildenstein.**

Screw Posts

Chicago screws add an industrial look to a piece and, since they come apart, are a good choice for a flexible binding technique. Chicago screws consist of two pieces—a "male" and a "female"—and are available in metal and plastic. Metal versions are screwed together by hand and are a standard aluminum. A brass finished Chicago screw is also made, but it is costlier and harder to find. Plastic screw posts are snapped together and are commonly available in black and white. Both metal and plastic screws can be created in custom colors for large quantities. Screw post bindings can be done by your hand-work source. Design Firm: Sayles Graphic Design.

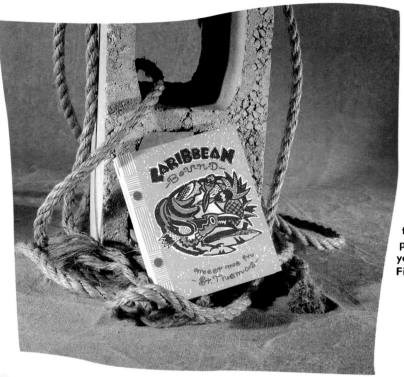

Eyelets

Eyelets are hollow, metal fasteners. An eyelet binding is a semi-automated process. Holes are pre-drilled, then the eyelets are fed through a track in an eyeletting machine. After the booklet is positioned, the eyelets are secured in place by a foot press. Eyelets can be set in uniform or random patterns. They can be left as is, or thread, yarn, ribbon or other material can be threaded through the eyelet holes to add dimension. Eyelets are available in different metals, colors and sizes. Eyelet bindings can be used on most any type of paper. If heavy paper is used with an eyelet binding, pages usually have to be scored so they can be turned easily. Design Firm: The Hilbert Agency, Inc.

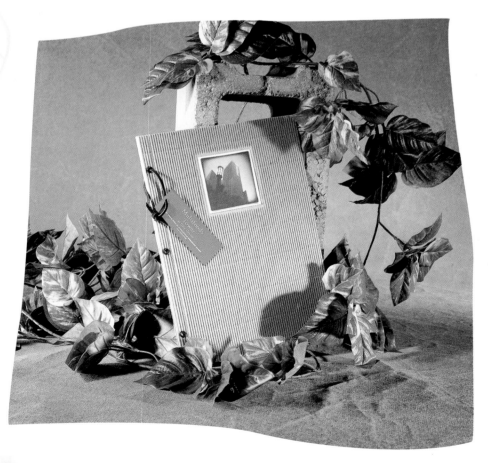

Staples

A vertical row of staples through a booklet's center spread is done by machine, creating a sharp spine. This method is not practical for a piece with a large number of pages, or with a piece made of thick material. And as shown here, a piece can also be side stitched: bound from front to back by a row, or rows, of staples in ordered or random fashion down the left margin. This is usually done by hand and is more expensive and time-consuming. Staples are available in different sizes and colors. Heavy industrial staples have recently gained in popularity and provide an alternative for a booklet warranting a more rugged-looking binding. **Design Firm: Little & Company.**

Wire

Wire-o spiral binding is a relatively inexpensive binding technique, depending on the length and width of spiral needed. Wire-o is priced by quantity. Booklets are fed by hand into a machine that punches the holes and threads the spiral wire. Wire-o is available in a wide range of stock colors and sizes, and if a large quantity is ordered it can be custom-made in any color or size. Plastic spiral loop is also available in several colors; it is, however, more expensive than metal. Spiral binding is especially useful for cookbooks, manuals, or any other piece that needs to lie flat when opened. **Design Firm: WYD Design.**

Found Object Bindings

A very dimensional type of binding is created by punching holes and securing an object to the front cover of a piece with a string, rubber band, or band of material, and knotting the material on the back cover. One long, thin object such as a pencil, rod or twig can make a unique binding, or an object can be tied through each hole. The variety of objects that can be used for bindings is limitless. Hardware, floral and craft shops are a good place to look for ideas. Design firm: Creative Services.

Tips for great design using unique bindings:

≥ Think of your binding method as an opportunity for creativity. There are many types of non-traditional bindings with virtually unlimited variations. Get ideas from hardware stores, junk stores, museum shops, art galleries, and book stores and from other related fields such as architectural and interior design.

≥ When choosing a binding, consider the depth of your project. For example, when binding with a metal hardware binding, such as Wire-o or Chicago screw posts, the size of the hardware should be proportioned to the depth of the pages.

≥ Always make a prototype (or have one made) using your chosen binding method with actual materials. Not only does the binding need to complement the design, it should be both sturdy and functional. The recipient needs to be able to open the piece easily and read everything inside. Covers and text consisting of heavy papers, chipboard and corrugated don't bend easily and may need to be scored, depending on the binding method you choose.

≥ Watch your art and copy margins! Some bindings may necessitate leaving larger margins; your prototype will help you resolve some of these issues in the early stages of the project.

≥ Source materials for your bindings early in the design process, or keep a stash and/or idea notebook of anything you find interesting for use in upcoming projects.

≥ Keep end use of the collateral piece in mind. For example, it would be unwise to use sticks or other sharp objects to bind a children's book or to use pointed or fragile things on an item that will go through the mail unprotected.

Gallery

This press kit for the National Museum of the American Indian is bound with jute twine and adorned with beads. In addition to serving a utilitarian function, the binding becomes an important design element, representative of the client it was developed for. **Design Firm: Grafik Communications Ltd.**

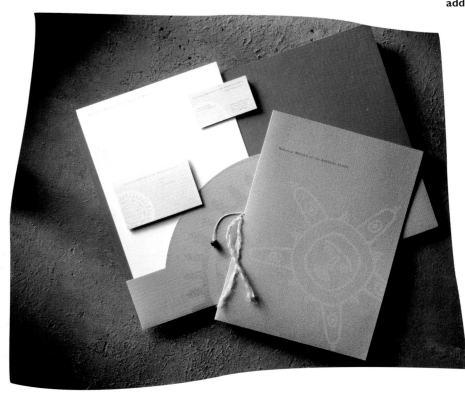

This presentation kit for a high-end printer features several unique binding techniques, such as zigzag sewing. The metal figures on the brochures and presentation folder are hand-tied with string and underscore the client's "pulling together" corporate theme. A total of 10,000 units were produced at a unit cost of $6.37. **Design Firm: Shannon Designs**

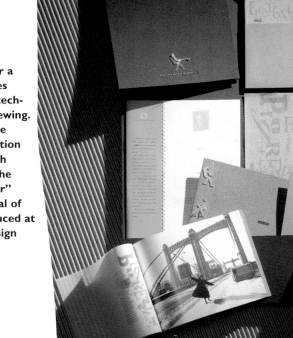

Seven 4" x 5½" photos were sewn into this catalog for a clothing boutique in Arizona. Each photo was first glued into place using a glue-stick so it could be sewn into the right place. Different color thread was used on the spreads to underscore the "Common Threads" theme and to complement each visual. At a total cost of $25,000, 3,500 catalogs were produced. Design Firm: Campbell Fisher Ditko Design

Two tree-shaped cards were sewn together with thread to form this unusual holiday greeting. Red and green thread echoed the primary ink colors the designer used for the piece. Design Firm: Kan Tai-keung Design & Associates Ltd.

Numerous hand operations were involved in this holiday card—including a tipped-on cover panel, hand-torn cover, ornament hang-tag and hand-sewn binding—making the project time-consuming to produce. One hundred cards were made with no hard cost to the designer due to trade arrangements with the various suppliers. Design Firm: Rickabaugh Graphics

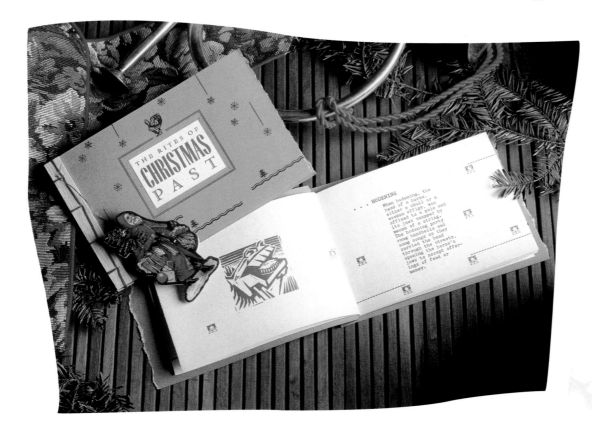

This portfolio promotion for the Portland office of THARP (and Drummond) DID IT was built around full-color reprints from a book about San Francisco graphic design that included a feature on the studio's home office in the Bay Area. The designers created a folder that was hand-bound with a corrugated cover attached with black grommets and a black elastic cord. The quotations are from partners Rick Tharp and Charles Drummond. Design Firm: THARP (and Drummond) DID IT

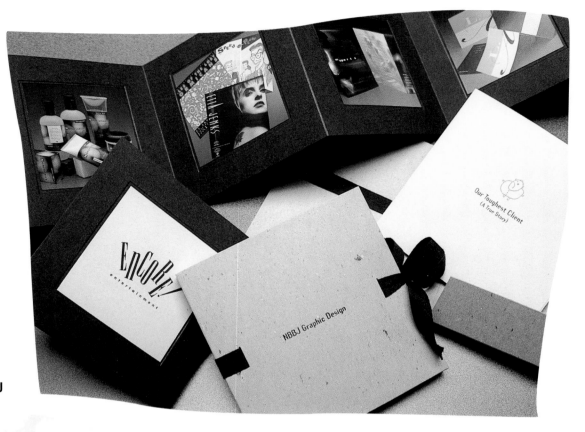

This highly flexible design firm promotion has windows, which allow images to be customized for the recipient of each piece. Each promotion was hand-tied with 24" of "twill tape" purchased at a local fabric store. Design Firm: **NBBJ Graphic Design**

The cover of this project—a low-budget catalog for a university exhibit—is unadorned chipboard. The title was attached with double-stick tape; additional copy on the cover was applied by using a rubber stamp. The binding is achieved with nuts, bolts and washers—an ideal way to bind a piece with a thick cover. The washers were spray painted black for effect. Design Firm: **Weaver Design**

A simple yet effective binding process works well for this 8¹/₂" x 28" poster/card. Seven hundred of the holiday cards were printed, each hand-bound by the designer/calligrapher with Perendale wool. Design Firm: Adams Art Lettering & Design

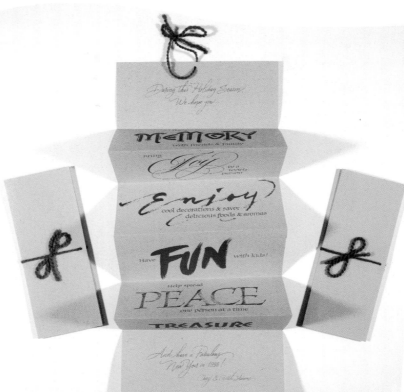

The concept for the Bank of China New Notes commemorative set is derived from ancient Chinese book containers. The box itself is made of peachwood, a material which is usually found in the making of furniture. Its interior includes a cloth-covered paper box with a copper clasp on top to join it with the outer wooden box. Inside, six albums contain the newly-issued notes as well as a certificate. Design Firm: Kan Tai-keung Design & Associates Ltd.

This two-level, limited-edition leather box, a gift to contributors to the Native American Indian Museum, is a celebration of the Native American creative process. The paper is handmade, the closures on each box were hand-crafted, and each unit was produced with a deer horn handle. Each box contains a portfolio, a silver piece, a diary and a video box. **Design Firm: Grafik Communications Ltd.**

This perfect-bound corporate brochure is finished off with the addition of a colored pencil. Held in place with two black rubber bands, the pencils were purchased directly from the European manufacturer. The project budget was $90,000; 5,000 were produced. **Design Firm: Shannon Designs**

This certificate's materials represent the three stages of the papermaking process—from wood to pulp to fine-grained paper. The wood branches are affixed with copper wire to a backing material of finished pulp. Pulp is produced in heavy sheets that are used in the stage prior to the manufacture of fine printing paper. The warped effect is intentional. The certificate is printed on Simpson Equinox, 100 percent recycled paper. **Design Firm: THARP DID IT**

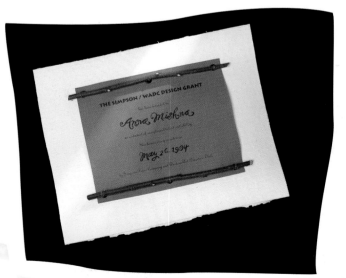

Glossary

Acrylic. A durable, plastic-like material with 30 times the impact strength of glass. Acrylic comes in various thickness and colors, and can be easily cut, engraved or screen-printed. Lucite and Plexiglas are common types of acrylic.

Airpressing. The process of bonding one material to another using an adhesive and forced air.

Benday. A technique involving laying a screen of lines, dots or other textures on top of an image to obtain various shadings and tones; since this reproduction method was commonly used in the early part of the twentieth century, it's often used to achieve a "retro" look.

Cell-cast process. A process by which acrylics are made in which the acrylic material is cast between glass plates, then baked; this process produces the highest quality acrylics.

Chicago screw posts. Available in metal and plastic and consists of two pieces, a "male" and a "female." Chicago screws add an industrial look to a piece and are a good choice for a flexible binding technique; however, the weight of the parts requires a thicker or heavier piece to work well as a binding method.

Chipboard. A material commonly used for packaging. Usually made of recycled paper and wood scrap pulp.

Corrugate. A type of cardboard with grooves and ridges (flutes). It comes in single-wall or double-wall strength. In single-wall corrugate, flutes are exposed on one side; double-wall has two pieces melded together with the flutes on the inside. Corrugate is priced by the test weight (weight that will crush the flutes) and sold by the square foot. It is commonly used for packaging and shipping.

Die-cutting. A method that uses sharp metal tools to cut special and unique shapes from printed or unprinted material. This can be done on flatbed or rotary presses. Die-cutting can be a great design tool for projects made with chipboard, acrylic, corrugated or any other material stiff enough to stand up to the process.

Embossing. Embossing is done after printing with two metal embossing dies, one relief (like a rubber stamp) and the other recessed. With extreme pressure and heat, the paper is placed between the two dies to create a raised image. Forms of embossing include blind, deboss and foil-embossed. Blind embossing refers to embossing done on an un-inked area. Debossing creates a recessed image.

Flexography. A form of letterpress printing on a web press that uses flexible, wraparound rubber plates and fast-drying inks. Flexography produces brilliant color and therefore is commonly used to print packaging, gift wraps and shopping bags. This process is practical only for large runs and designs with few details because of its tendency to shift during printing.

Fly sheets or fly leaves. In book binding, endpapers that are not pasted to the covers of the book.

Halftone. A reproduction of a continuous-tone picture, through a contact screen, which converts the picture into dots of various sizes and tones. Letterpress and offset printing produce images without tonal gradation, therefore making it necessary to convert continuous-tone values so they can be seen. The result is actually an optical illusion, making the printed halftone look as though it were printed with varying ink densities and values.

Hand-tied binding. A method of binding in which thread, cord, yarn, ribbon or other material is looped around the cover of a booklet and tied by hand, requiring either a small quantity or many sets of hands. This type of binding is flexible and is commonly used for restaurant menus; since this is a fairly loose type of binding, it is not practical for booklets with a large number of pages.

Japanese-sewn binding. A type of binding which consists of thread, yarn, string, ribbon, raffia, twine, rope, wire or other material hand-sewn through a pattern of holes. The material is looped and tied through holes in a continuous pattern; this creates a looser binding than a machine-sewn binding. This is the most expensive type of binding because the amount of hand-work involved is time-consuming.

Kraft paper. Strong paper, usually brown, made from sulfate pulp.

Letterpress. A method of printing that involves cast metal type or plates on which areas to be printed are raised above the areas that will go unprinted. Ink rollers touch only the raised areas, then the metal plates are applied to the paper. The impression left by the cast metal plates is sharp and clear, though more subtle (and less expensive) than embossing. The oldest method of printing, it can be used for newspapers, magazines, books, packaging and specialty papers.

Machine-sewn binding. A method of binding in which a booklet is sewn down the spine or side-stiched down the left side on a heavy-duty sewing machine. Since machine stitching is tight, this process requires a strong thread. Machine-sewn bindings are less expensive than Japanese-sewn bindings, since the process is quicker and requires less handwork.

Melt-calendaring process. A method of manufacturing acrylic in which the acrylic is extruded from a machine and rolled between stainless steel belts under high temperatures.

Offset lithography. A printing method based on the principle that oil and water don't mix. Although both the image and non-image area lie on the same plane, the image to be printed is chemically treated so it will receive ink but repel water; the non-image area is treated to repel ink. To print, the ink is transferred, or offset, to a rubber blanket then rolled onto paper. This is the most popular of printing processes because it can print on a wide range of textures.

Pamplet-sewn binding. A hand-sewn method of binding in which the stitches are hidden. Stitching can be done on the front or back of the booklet, off the spine edge. The knot that secures the thread is usually hidden in the inside center, but can be moved to the outside of the book to add an attractive design element.

Perfect binding. An inexpensive binding technique in which pages are glued together rather than sewn. This method is primarily used for small manuals, paperback books, magazines and thicker brochures.

Saddle stitch. A binding process in which a staple, or saddle wire, is put through the middle of the fold to keep the pages together; this process is usually used for thin pieces, such as pamphlets and small brochures.

Silk screening. A printing process in which a mesh frame and a stencil are used, along with a squeegee, to apply ink to a surface. The mesh areas are printed by the ink, but the stenciled areas are not. Practically any flat surface—wood, glass, metal, plastic, fabric, cork or paper—can be printed using this process. However, there are some drawbacks: this process can be time-consuming, especially if you're applying more than one ink color to the same piece (you'll need to allow extra time for the ink to dry between applications), and this process doesn't render detail well. However, if you use finer screen and thinner ink, you'll get a sharper image than you would if you use a thicker screen and ink.

Silicone. A clear bonding agent. Because of silicone's transparency, it is commonly used with acrylics so any residue won't be seen. It can be purchased at your local hardware store.

Thermography (or raised printing). A printing process in which non-drying inks are used to print and then are dusted with a powder compound; then the image is placed under heat, which fuses the ink and powder together. This process creates an effect that is similar to engraving, but less expensive. Thermography is commonly used on stationery, greeting cards, invitations and paper decorations.

Wire-O binding. A binding process in which a continuous double series of wire loops run through punched slots along the binding side of a brochure. Sheets won't easily fall out, and images and text won't be lost in the binding. Some designers who use this binding method often choose to buy a Wire-O binding machine and bind pieces themselves in their studio.

Directory, Permissions and Credits

All the following pieces are used by permission.

ACURIX DESIGN GROUP
Marc Shereck
655 Southpointe Court, Suite 201
Colorado Springs, Colorado 80906
• Pages 38-39.

ADAMS ART
Cheryl Adams
2124 NW 139th Street
Des Moines, Iowa 50325
• Page 130, © Cheryl O. Adams. Designer/illustrator: Cheryl O. Adams; title: Holiday Accordion Poster/Card.

AFTER HOURS CREATIVE
Russ Haan
1201 E. Jefferson
Phoenix, Arizona 85034
• Page 14, ©1993 After Hours Creative. Designer: Brad Smith; copywriter: Russ Haan; title: Moving Announcement; client: After Hours Creative.
• Page 42, © 1993 After Hours Creative. designer: Todd Fedell; copywriter: Russ Haan; title: Image Brochure for Bed & Breakfast.

AKAGI REMINGTON DESIGN
Doug Akagi
632 Commercial Street
San Francisco, California 94111
• Page 42, © Akagi Remington Design. Art director: Doug Akagi; designers: Doug Akagi, Kimberly Powell; illustrator: Hirashi Akagi; title: Save San Francisco Bay; client: AIGA/San Francisco Chapter.

BLUE SKY DESIGN
Robert Little
6401 SW 132 Ct. Circle
Miami, Florida 33183
• Page 54, © Blue Sky Design. Designers: Joanne Little, Robert Little; engraving: Pfaff Engraving; title: Pfaff/Carpenter Wedding Invitation.

• Page 70, © Blue Sky Design. Designer: Robert Little; sculptor: Barry Massin, title: AIGA/Miami Design Leadership Awards, client: AIGA/Miami.

BRAINSTORM, INC.
Chuck Johnson
3347 Halifax
Dallas, Texas 75247
• Pages 21-25, © Brainstorm , Inc.
• Page 28, © 1993 Brainstorm, Inc. Creative director: Chuck Johnson; art director: Ken Koester; designers/ illustrators: Chuck Johnson, Ken Koester, Rob Smith; title: Brainstorm Christmas Card; client: Brainstorm, Inc.

BUSINESS INCENTIVES PERFORMANCE SERVICES
Sandra Carlin
7625 E Bush Lake Road
Edina, Minnesota 55435
• Page 122, © BI Performance Services. Creative Director: Wendy Fernstrum; designers: Amy Usdin and Michelle Lindgren; production artist: Michael Heisler; electronic assembly: Riverside Color; printer: Diversified Graphics; title: CPI Announcement Brochure.

CAMPBELL FISHER DITKO DESIGN
Steve Ditko
3333 E. Camelback Road, Suite 200
Phoenix, Arizona 85018
• Page 29, © 1994 Crasharts. Designers: Steve Ditko, Charles Wilkin, Helen Heston; title: Alternatives.
• Page 40, © 1993 Uh, Oh Clothing Boutique. Art director/designer: Steve Ditko; illustrator: Luis Tomas; copywriter: Jill Spear; photographer: Rick Rusing; title: Studies of Christiana; client: Uh, Oh Clothing Boutique.
• Page 44, © 1990 Uh, Oh Clothing Boutique. Art director/designer: Steve Ditko; copywriter: Jill Spear; photographer: Rick Rusing; title: Changes; client: Uh, Oh Clothing Boutique.
• Page 127, © 1991 Uh, Oh Clothing Boutique. Art director/designer: Steve Ditko; copywriter: Jill Spear; photographer: Rick Rusing; sewer: Josephine Katula; title: Common Threads; client: Uh, Oh Clothing Boutique.

CATO GOBÉ & ASSOCIATES
Leslie Sherr
411 Lafayette Street
New York, New York 10003
• Page 94, © Cato Gobé & Associates. Creative director: William Hovard; design director: Alexandra Min; designer: Tom Davidson; group account director: Leah Caplan; title: Trail Guide; client: Abercrombie & Fitch.
• Page 113, © Cato Gobé & Associates. Creative director: William Hovard; design director: Alexandra Min; designer: Tom Davidson; group account director: Leah Caplan; title: Promotional packaging for Abercrombie & Fitch; client: Abercrombie & Fitch.

CHARLES ZUNDA DESIGN CONSULTANTS
Charles Zunda
80 Mason Street
Greenwich, Connecticut 06830
• Page 16, © Charles Zunda Design Consultants, Inc. Art director/designer: Charles Zunda; title: CZDC self Promotion Holiday Wine; client: CZDC.
• Page 103, © Charles Zunda Design Consultants, Inc. Art director/designer: Charles Zunda; title: Self Promotion-Oil & Vinegar; client: Charles Zunda Design Consultants.

CLIFFORD SELBERT DESIGN
Clifford Selbert
2067 Massachusetts Avenue
Cambridge, Massachusetts 02140
• Page 115, © 1990 Clifford Selbert Design. Designers: Lynn Riddle, Clifford Selbert; title: Double Vision Award; client: Society of Environmental Graphic Design.

CREATIVE SERVICES
Nancy Cech
120 Howard Street
San Francisco, California 94105
• Page 125, © Pacific Bell Directory. Designer: Maria Majeski; writer: Nancy Swasey; photographer: Pierre-Yves Gravec; printer: Diversified Graphics, Inc.; title: Recycling Brochure; client: Pacific Bell Directory.

DESIGN SERVICES, INC.
Rod Parker
7809 Jefferson Hwy., Suite D-3
Baton Rouge, Louisiana 70809
• Page 105, © Design Services, Inc. Art director:
Rod Parker; designer/illustrator: Tim Hope; video
package: Erskin Mitchell; title: Walsh
Cinematography Video Packaging; client: Walsh
Cinematography.

DETTER GRAPHIC DESIGN
Jeanne Detter
4222 Milwaukee Street, Suite 17
Madison, Wisconsin 53714
• Page 15, © 1994 Detter Graphic Design. Art
director/ designer: Jeanne Detter; title: 1994
Christmas Promotion/Card; client: Detter
Graphic Design

DIVERSIFIED GRAPHICS
Lisa Henkemeyer
1700 Broadway NE
Minneapolis, Minnesota 55413
• Page 119.

SHARP EMMONS
P.O. Box 1824
5017 Sims Road
Knoxville, Tennessee 37901
• Page 62, © 1993 Sharp Emmons.

EQUITY GROUP
Peter Szollosi
2 N Riverside Plaza
Chicago, Illinois 60606
• Pages 81-85, Equity Group.

GRAFIK COMMUNICATION
Judy Kirpich
1199 N. Fairfax Street, Suite 700
Alexandria, Virginia 22314
• Page 18, © 1991 Gilbert Paper. Designers:
Melanie Bass, Gregg Glaviano, Judy Kirpich;
copywriter: Jake Pollard; photographer: Claude
Vasquez; title: Gilbert Paper Promotional Kit;
client: Gilbert Paper.
• Page 57, © 1991 Systems Center. Designers:
Gregg Glaviano, Judy Kirpich; illustrator: Gregg
Glaviano; copywriter:Jake Pollard, title: Turning
up the Heat.
• Page 126, © 1993 National Museum of the
American Indian. Designers: Melanie Bass, Julie
Sebastianelli, Judy Kirpich; illustrator: Linley
Logan; title: National Museum of the American
Indian Press Kit; client: National Museum of the
American Indian.
• Page 131, © 1993 Native American Indian
Museum. Designers: Gregg Glaviano, Julie
Sebastianelli, Judy Kirpich; title: Native American
Indian Commemorative Gift Box for Donors;
client: Native American Indian Museum.

THE HILBERT AGENCY

Gary Hilbert
430 First Avenue North
Minneapolis, Minnesota 55401
Page 123, © The Hilbert Agency. Art
director/designer: Gary Hilbert; copywriter: Vira
Viner; typography: About Face Typographers;
photography: Brady Willette; title: Multifoods
Tower (Minneapolis) Leasing Brochure; client:
Brookfield Development, Inc.

HORNALL ANDERSON DESIGN WORKS
Jack Anderson
1008 Western Avenue, Suite 600
Seattle, Washington 98104
• Page 56, © Hornall Anderson Design Works.
Art directors/designers:Jack Anderson, John
Hornall; illustrator: Greg Walters; copywriter:
John Hornall; title: Drywall Invitation; client:
Hornall Anderson Design Works.
• Page 62, © Hornall Anderson Design Works.
Art directors: Jack Anderson, John Hornall;
designers: Jack Anderson, John Hornall, Cliff
Chung, title: Weyerhaeuser Invitation; client:
Weyerhaeuser.
• Page 105, © Hornall Anderson Design Works.
Art director: Jack Anderson; designers: Jack
Anderson, Luann Bice; illustrator: Kurt
Holloman; title: Discover the Difference Wooden
Plaque; client: Food Services of America.
• Page 112, © Hornall Anderson Design Works.
Art directors: Jack Anderson, John Hornall;
Designers: Jack Anderson, John Hornall, Julie
Lock; illustrator: Julie Lock; copywriter: John
Hornall; title: Metal Invitation; client: Hornall
Anderson Design Works.

JEFF LABBÉ DESIGN
Jeff Labbé
218 Princeton Ave
Claremont, California 91711
• Page 93, © Jeff Labbé Design. Art
director/designer: Jeff Labbé; copywriters: Finbar
O'Keeffe, Jeff Labbé; photographer: Kimball
Hall; title: Designers Stew; client: Jeff Labbé
Design.
• Page 117, © 1994 Jeff Labbe' Design.
Designer/copywriter: Jeff Labbe'; photographer:
Kimball Hall; title: Peace Xmas '94; client: Jeff
Labbé Design.
• Page 115, © Jeff Labbé Design. Art
director/designer: Jeff Labbe'; photographer:
Kimball Hall; title: Design 0950 Rescue Mirror
Card; client: Jeff Labbé Design.

JERUSALEM PAPERWORKS
Alan Potash
5017 S 24th Street
Omaha, Nebraska 68107
• Page 16.

JULIA TAM DESIGN
Julia Tam
2216 Via La Brea

Palos Verdes, California 90274
• Page 16, © Julia Tam Design. Art
director/designer: Julia Tam; title: Julia Tam
Christmas Card; client: Julia Tam.

KAN TAI-KEUNG DESIGN ASSOCIATES
Diana Yiu
28/F Great Smart Tower
230 Wanchai Road
Hong Kong
• Page 70, © Kan Tai-keung Design &
Associates. Art director/designer: Freeman Lau
Siu Hong; title: Lorenzo Ristorante Italiano
menu; client: Lorenzo Ristorante Italiano.
• Page 127, © Kan Tai-keung Design &
Associates Ltd. Art director/designer: Kan Tai-
keung; title: Ragence Lam Xmas Card; client:
Ragence Lam Ltd.
• Page 130, © Kan Tai-keung Design &
Associates Ltd. Art directors: Kan Tai-keung,
Freeman Lau Siu Hong, Eddy Yu Chi Kong;
designers: Kan Tai-keung, Freeman Lau Siu
Hong, Eddy Yu Chi Kong, Joyce Ho Ngai Sing,
Janny Lee Yin Wa, title: Bank of China New
Notes Commemorative Set; client: Bank of
China.

LITTLE & COMPANY
Paul Wharton
1010 S. Seventh Street
Minneapolis, Minnesota 55415
Page 124, © 1994 Cross Pointe Paper Corp.
Creative director: Paul Wharton; designer: Mike
Lizama; writer: Sandra Burholtz; printer:
Diversified Graphics, Inc.; title: "Ize" on
Medallion; client: Cross Pointe Paper
Corporation.

LOVE PACKAGING
Brian Miller
410 E 37th Street N.
Plant 2, Graphics Department
Wichita, Kansas 67219
• Pages 9-13, © Love Packaging.

MATSUMOTO, INC.
Takaaki Matsumoto
17 Cornelia Street
New York, New York 10014
• Page 14, © Matsumoto Incorporated. Art direc-
tor/designer: Takaaki Matsumoto; title: Catalog
for Knoll Furniture; client: Knoll Furniture.
• Page 43, © Matsumoto Incorporated. Art direc-
tor/designer: Takaaki Matsumoto; title: Holiday
Greeting Card; client: M Plus M Incorporated.
• Page 60, © Matsumoto Incorporated. Art direc-
tor: Takaaki Matsumoto; designer: Takaaki
Matsumoto; authors: Lynn Gumpert, Richard
Martin; editor: Kate Norment; title: Material
Dreams; client: The Gallery at Takashimaya, New
York.
• Page 112, © Matsumoto Incorporated. Art
director/designer: Takaaki Matsumoto; title:

Catalog for Comme des Garçons; client: Comme des Garçons.

MAUK DESIGN
Mitchell Mauk
636 Fourth Street
San Francisco, California 94107
•Page 45, © Mauk Design. Art direction/design: Mitchell Mauk; title: Oracle Acapulco Invitation; client: Oracle Software.
• Page 73, © Mauk Design. Art director/designer: Mitchell Mauk; title: Windows Magazine Invitation; client: Windows Magazine.

MILLER MEASTER ADVERTISING
• Page 121, © 1994 American Crystal Sugar Co. Design: Miller Measter Advertising; title: 1994 Annual Report; client: American Crystal Sugar Company.

MIRES DESIGN
Anne Brower
2345 Kettner Blvd.
San Diego, California 92101
• Page 19, © Mires Design, Inc. Art director: José Serrano; designers: José Serrano, Scott Mires; photographer: Chris Wimpey; title: Mires Design Moving Announcement; client: Mires Design.

MODERN ILLUSTRATIONS
Janice Lowry
1116 N. French Street
Santa Ana, California 92701
• Page 58, © 1994 Modern Illustrations. Art director: Janice Lowry; designers: Janice Lowry, Jon Gothold; title: Personal Profile.

NBBJ GRAPHIC DESIGN
Stefanie Choi
111 S. Jackson Street
Seattle, Washington 98104
• Page 19, © 1993 NBBJ Graphic Design. Art director/ designer: Doug Keyes; title: Green Seating Tour Press Kit; client: NBBJ.
• Page 54, © 1991 NBBJ Graphic Design. Art director/ designer: Stefanie Choi; title: Christmas Party Program; client: NBBJ Graphic Design.
• Page 113, © 1989 NBBJ Graphic Design. Art director/ designer: Doug Keyes; silkscreener: Chip Wyly; title: San Francisco Open House Invitation; client: NBBJ San Francisco.
• Page 129, © NBBJ Graphic Design. Art director: Kerry Burg; designers: Joe Cachero, Stefanie Choi, Susan Dewey, Doug Keyes, Klindt Parker, Margo Sepanski; illustrator: Klindt Parker; copywriter: Dylan Tomine; title: NBBJ Graphic Design Self-Promotion; client: NBBJ Graphic Design.

NEWTON/STOVER DESIGN & ILLUSTRATION
Ron Newton
106 W. Ninth Street

Vancouver, Washington 98660
• Page 72, © Newton/Stover Design & Illustration. Designers: Amy Stover, Ron Newton; Illustrator: Ron Newton; title: Elvis Fishing Lure Promotion; client: Newton/Stover Design & Illustration.
• Page 114, © Newton/Stover Design & Illustration. Designers: Amy Stover, Ron Newton; illustrator: Ron Newton; title: Craftsman Coffee; client: The Handwerk Shop.

NORGAARD GRAPHIC DESIGN
Barry Norgaard
1339 47th Street
Des Moines, Iowa 50311
• Page 61, © Norgaard Graphic Design. Art director/designer/illustrator: Barry Norgaard; title: ADAI Invitation; client: Art Directors Association of Iowa.

PACEWILDENSTEIN
Paul Pollard
32 E 57th Street
New York, New York 10012
• Page 122, © 1995 PaceWildenstein. Design/production: Tomoko Makiura and Paul Pollard; title: Printed Beginnings and Ends.

PALAZZOLO DESIGN
John Ferin
6410 Knapp Northeast
Ada, Michigan 49301
• Pages 87-91.
• Page 92, ©Palazzolo Design Studio. Art director/designer: Gregg Palazzolo; title: Urban Institute for Contemporary Arts brochure; client: Urban Insititue for Contemporary Arts.
• Page 116, ©Palazzolo Design Studio. Art director/designer: Gregg Palazzolo; title: American Mettle.

PARKS & RECREATION DEPARTMENT
City of Colorado Springs
Denise A. Sherwood
1401 Recreation Way, P.O. Box 1575
Colorado Springs, Colorado 80901
• Pages 31-37.

PICTOGRAM STUDIO
Stephanie Hooton
1740 U Street NW, Suite 2
Washington, D.C. 20009
• Page 56, © Pictogram Studio Inc. Designers: Stephanie Hooton, Hien Nguyen; title: Little Red Boxes; client: Pictogram Studio.
• Page 60, © Pictogram Studio Inc. Designers: Stephanie Hooton, Hien Nguyen; title: Holiday Greeting.

PLUS DESIGN INC.
Anita Meyer
25 Drydock Avenue
Boston, Massachusetts 02210

• Page 17, © 1992 plus design inc. Art director: Anita Meyer; designers: Anita Meyer, Matthew Monk, Jan Baker; title: Alcan Architecture 1992; client: Alcan Aluminum Ltd.
• Page 47, © plus design inc. Art director: Anita Meyer; designers: Anita Meyer, Jan Baker; title: Anita Meyer and Andrew Brown Wedding Invitation.
• Pages 49-53.
• Page 95, © plus design inc. Art directors: Anita Meyer, Karin Fickett, Matthew Monk, Dina Zaccagnini; designers: Anita Meyer, Karin Fickett, Matthew Monk, Dina Zaccagnini, Jan Baker; title: plus design inc. 1994 gift; client: plus design inc.

PRIMO ANGELI INC
Jean Galeazzi
590 Folsom Street
San Francisco, California 94105
• Page 104, © Primo Angeli Inc. Art director/designer: Primo Angeli; title: Mixed Media: Xeroxed Wood.

RICKABAUGH GRAPHICS
Eric Rickabaugh
384 W. Johnstown Road
Gahanna, Ohio 43230
• Page 128, © 1992 Rickabaugh Graphics. Art director: Eric Rickabaugh, Marie Krumel; designer/illustrator/ copywriter: Michael Tennyson Smith; title: 1992 Christmas Card; client: Rickabaugh Graphics.

ROBERT PADOVANO DESIGN
Robert Padovano
538 82nd Street
Brooklyn, New York 11209
• Page 58, © Robert Padovano Design. Art director/designer: Robert Padovano, title: Christmas Gift Box; client: Robert Padovano Design.

SAYLES GRAPHIC DESIGN
John Sayles
308 Eighth Street
Des Moines, Iowa 50309
• Page 27, © Sayles Graphic Design. Art director/designer/ illustrator: John Sayles; copywriter: Mary Bell; title: San Antonio "Get A Feel For It."
• Page 28, © Sayles Graphic Design. Art director/designer/ illustrator: John Sayles; title: Success By the Book; client: University of California at Santa Barbara.
• Page 29, © Sayles Graphic Design. Art director/designer/ illustrator: John Sayles; copywriter: Andy Tebockhorst; title: Working Without Annette; client: The Flying Marsupials.
• Page 47, © Sayles Graphic Design. Art director/designer/ illustrator: John Sayles; title: Art in the Park poster; client: Des Moines Art Center.
• Pages 65-69.
• Page 71, © Sayles Graphic Design. Art director/designer/ illustrator: John Sayles; copywriter:

Wendy Lyons; title: Pac-Link; client: Berlin Packaging.
• Page 73, © Sayles Graphic Design. Art director/designer/ illustrator: John Sayles; title: Hillside Neighborhood Penset.
• Page 94, © Sayles Graphic Design. Art director/designer/ illustrator: John Sayles; copywriters: Wendy Lyons, Jania Stone; title: Happy Trails; client: Panache.
• Page 123, © Sayles Graphic Design. Art director/designer/illustrator/copywriter: John Sayles; title: Caribbean Bound: National Travelers Life (NTL) 85th Anniversary.

SEGURA INC.
Carlos Segura
361 W. Chestnut Street, First Floor
Chicago, Illinois 60610
• Page 41, © Segura Inc. Art director: Carlos Segura; title: New Year's Card; client: MRSA Architects.
• Page 45, © Segura Inc. Art director: Carlos Segura; title: Moving Announcement; client: Elements.

SHANNON DESIGNS
Alyn Shannon
3536 Edmond Blvd.
Minneapolis, Minnesota 55406
• Page 41, © 1995 Diversified Graphics Incorporated. Designer: Alyn Shannon; copywriter: Debbie Kuehn; title: Holiday Card/Kwanza; client: Diversified Graphics Incorporated.
• Page 46, © 1994 Diversified Graphics Incorporated. Art director: Alyn Shannon; designers: Alyn Shannon, Jane Perman; title: Specialty Cards; client: Diversified Graphics Incorporated.
• Page 59, © 1994 Diversified Graphics Incorporated. Designer: Alyn Shannon; copywriter: Debbie Kuehn; title: Open House Invitation; client: Diversified Graphics Incorporated.
• Page 63, © 1994 Shannon Designs. Art director: Alyn Shannon; title: Marathon Invitation; client: Jeff Gacek.
• Page 126, © 1994 Diversified Graphics Incorporated. Designer: Alyn Shannon; photographer: Craig Perman; title: Diversified Graphics Business Presentation Kit; client: Diversified Graphics Incorporated.
• Page 131, © 1994 Control Graphics. Designer: Alyn Shannon; copywriter: Debbie Kuehn; title: Control Graphics Corporate Capabilities Brochure; client: Control Graphics.

SHIMOKOCHI/REEVES
Tracy McGoldrick
4465 Wilshire Blvd., Suite 100

Los Angeles, California 90010
• Page 27, © 1992 Shimokochi/Reeves. Designers: Mamoru Shimokochi, Anne Reeves; title: Marketing and Communication Materials; client: Shimokochi/ Reeves.

STEELHAUS DESIGN
Richard Smith
4991 Eller Road
Chattanooga, Tennessee 37416-1820
• Page 116, © 1994 Steelhaus. Art director/designer: Richard L. Smith; title: STEELHAUS — An Introspective; client: Steelhaus.

STUDIO M D
Jesse Doquilo
1512 Alaskan Way
Seattle, Washington 98101
• Page 17, © Studio M D. Art directors: Jesse Doquilo, Randy Lim, Glenn Mitsui; designer: Jesse Doquilo; title: Thank You Notes; client: Studio M D.
• Page 40, © Studio M D. Art director: Randy Lim; designers: Randy Lim, Elana Lim; title: Lim Baby Announcement.
• Page 56, © 1991 Studio M D. Art directors: Jesse Doquilo, Randy Lim, Glenn Mitsui; title: Studio M D Handmade Book; client: Studio M D.

THARP DID IT
Rick Tharp
50 University Avenue, Suite 21
Los Gatos, California 95030
• Page 43, © THARP DID IT. Designers: Rick Tharp, Jana Heer, Colleen Sullivan; title: Napa Valley Grille Wine List Cover.
• Page 128, © THARP (and Drummond) DID IT. Art directors: Rick Tharp, Jana Heer; copywriters: Rick Tharp, Charles Drummond; title: THARP (and Drummond) DID IT Portfolio; client: THARP (and Drummond) DID IT.
• Page 131, © 1994 Western Art Directors Club. Art directors: Rick Tharp, Jana Heer, Laurie Okamura; calligrapher: Georgia Deaver; title: Simpson Paper Company/Western Art Directors Club Design Grant; client: Western Art Directors Club.

THREE FISH DESIGN
Caroline Vaaler
713 Westover Avenue
Norfolk, Virginia 23507
• Pages 75-79, © Three Fish Design.

ULTIMO INC.
Clare Ultimo
41 Union Square West, Suite 209
New York, New York 10003

• Page 26, © 1991 Ultimo, Inc. Art director: Clare Ultimo; designers: Joanne Obarowski, Clare Ultimo; title: The Bread Gift; client: Ultimo, Inc.
• Page 55, © 1990 Ultimo, Inc. Art director: Clare Ultimo; designer: Julie Hubner; title: The Tree Gift; client: Ultimo, Inc.
• Page 61, © 1992, Ultimo, Inc. Art director: Clare Ultimo; designer: Joanne Obarowski; title: The Coin Gift.
• Page 92, © 1993 Ultimo, Inc. Art director: Clare Ultimo; designers: Adrienne Assaff, Suzanne Di Resta, Shannon Rogan; illustrator: Adrienne Assaff; title: The Book Gift.

WAMSUTTA
Deborah Russo
1285 Avenue of the Americas
34th Floor
New York, New York 10019
• Page 44, © Wamsutta. Art director/designer: Deborah Russo; photographer: Stewart Ferebee; title: Bedtrends.

WEAVER DESIGN
Marie Weaver
2157 Vestridge Drive
Birmingham, Alabama 35216-3340
• Page 129, © 1994 The Board of Trustees of the University of Alabama. Designer: Marie Weaver; title: Ferrously Yours; client: Visual Arts Gallery, University of Alabama at Birmingham.

WIGGIN DESIGN, INC.
Gail Wiggin
6 Thorndal Circle
Darien, Connecticut 06820
• Page 120, © Wiggin Design, Inc. Photographer: Amos Chan; title: MasterCard International invitation.

WYD DESIGN INC.
David Dunkelberger
61 Wilton Road
Westport, Connecticut 06880
• Page 124, © WYD Design. Production manager: Suzie Yannes; art director: Frank J. Oswald; designers: David Dunkelberger and Scott Kuykendall; photographer: Gerald Shaun Bybee Studio; illustrator: WYD Design; title: ZRC Identity Brochure "Strong Points"; client: Zurich Reinsurance Center, Inc.

ZUBI DESIGN
Kristen Balouch
57 Norman Avenue, Suite 4R
Brooklyn, New York 11222
• Pages 97-102, © Zubi Design.
• Page 104, © 1994 Zubi Design. Designers: Kristen Balouch, Omid Balouch; title: 1994 Boxart Christmas Gift; client: Boxart.

Index